M000250085

IMAGES
of America

ITALIAN AMERICANS OF NEWARK, BELLEVILLE, AND NUTLEY

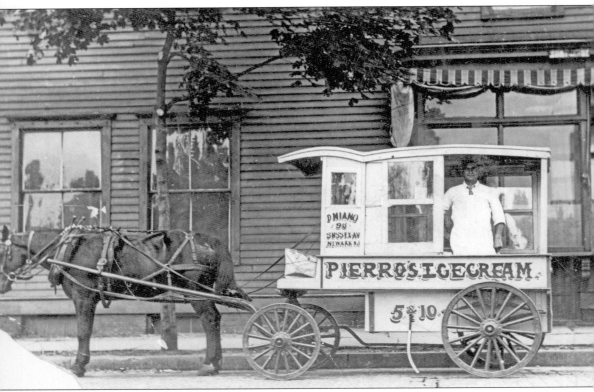

Around 1930, Domenico Miano looks out from his cousin's ice-cream truck. Ice cream was 5¢ and 10¢. The name Miano and Domenico's address appear on the sign on Pierro's ice-cream truck. Domenico immigrated to Newark in 1910, at the age of 17, from Ariano Irpino, Avellino. When he was 21, he married 19-year-old Maria Nicola Liloia, herself an immigrant from Teora. They lived on Acqueduct Alley in the old First Ward of Newark, before moving to 96 Sussex Avenue. They had three children, Carmela, Lorenzo, and Filomena.

On the cover: Please see above. (Courtesy Rev. Thomas D. Nicastro Jr.)

IMAGES
of America

ITALIAN AMERICANS OF NEWARK, BELLEVILLE, AND NUTLEY

Sandra S. Lee, Ph.D.

ARCADIA
PUBLISHING

Copyright © 2008 by Sandra S. Lee, Ph.D.
ISBN 978-0-7385-5728-1

Published by Arcadia Publishing
Charleston SC, Chicago IL, Portsmouth NH, San Francisco CA

Printed in the United States of America

Library of Congress Catalog Card Number: 2007936767

For all general information contact Arcadia Publishing at:
Telephone 843-853-2070
Fax 843-853-0044
E-mail sales@arcadiapublishing.com
For customer service and orders:
Toll-Free 1-888-313-2665

Visit us on the Internet at www.arcadiapublishing.com

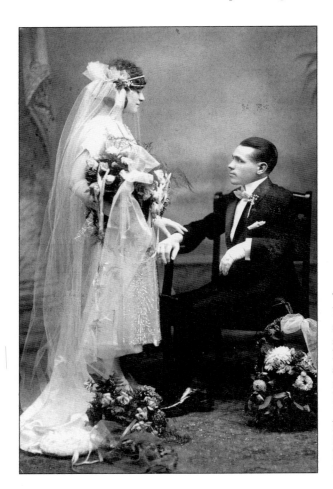

The photographs and stories in this book portray family, connection, and new beginnings—a new life in a new land. Yet the past remains, in hearts and minds. This photograph symbolizes a new beginning, the marriage of Enrico Stefanelli to Elizabeth Ventre on October 23, 1921, at St. Lucy's Church in Newark. Enrico was born in the "old land" (Teora), while Elizabeth was born in the "new land" (Newark). (Courtesy John Rendfrey.)

CONTENTS

ACKNOWLEDGMENTS

So many people have contributed photographs and family stories, giving generously of their time for this book. Those who contributed photographs have been noted in the courtesy lines throughout the book. I also thank our ancestors, some of whose lives are portrayed here, for all they accomplished and taught us.

Joseph DePierro, dean of the College of Education and Human Services at Seton Hall University, and William Connell, former director of the Charles and Joan Alberto Institute of Italian Studies and current holder of the La Motta Chair in Italian Studies at Seton Hall, helped to inspire and shape this project. Mike Soupios and Tara Hendricks at the Teaching, Learning, and Technology Center of Seton Hall University provided technical support and expertise for the scanning of photographs. Alan Delozier, of the Msgr. William Noe Field Archives and Special Collections, Seton Hall University, and Bonnie Sauer, of the Peter W. Rodino Jr. Papers, Seton Hall University School of Law, made available archival material.

Gabriella Romani, Jessica Cerezo, Rev. Innocent Okozi, Constance P. Ferrante, Richard Stern, Donato DiGerionimo, Angela Raimo, Mary Lou Scottino, Mary Scholl, John Rendfrey, and Lucy Vazquez assisted this project in innumerable ways. I am also grateful to my editor, Erin Rocha.

Oral and written histories and "old neighborhood" tours were provided by Paula Zaccone, Emanuele Alfano, Anthony J. Iannarone, Joseph Cervasio, Ralph Vitillo, Al Quaresimo, Phyllis Marie Cupparo, Mary Ann Stenzel, Marianne Pepe Murray, Samuel J. Fusaro, Gerard Tolve, Mary C. Kenny, Lawrence Costello, Steven Mairella, Andrew Ruffo, Andrew Mastandrea, and Frances and Ernie Cabalbo.

Additional information was obtained from newspapers, including the *Italian Tribune*, the *Nutley Sun*, and the *Belleville Times*. The Short Hills Family History Center has been an important resource.

For creative inspiration, I am grateful to my first teachers, Robert and Irma Lee, my parents, and to Luis Barranon, my husband.

Partial financial support for this project has been provided by the Charles and Joan Alberto Institute of Italian Studies at Seton Hall University; UNICO National, Nutley Chapter; UNICO National, Belleville Chapter; and Steven Mairella.

INTRODUCTION

Who were the Italian immigrants who crossed the ocean to settle in Newark, Belleville, and Nutley? Who were their family members and descendants? What was life like in the Italian neighborhoods? Using vintage photographs from family albums, we will journey through the Italian communities of Newark, Belleville, and Nutley, from the 1900s to the 1950s, with an emphasis on the early years.

We will explore the images that have been preserved by family members themselves. These vintage photographs represent a "slice of life" from the past and have been selected from more than 3,000 photographs reviewed. They have been collected from family albums and library archives. Most have never before been published.

Italian Americans today make up almost 20 percent of the population of New Jersey, the largest ethnic group in the state. There have been Italians in New Jersey since Colonial times. In 1870, there were 257 Italians in New Jersey. By far, the largest numbers of Italian immigrants, however, came in the 1880s and beyond, mostly from the southern regions of Italy.

Both Nutley and Belleville were originally part of Newark. In 1812, Bloomfield (including Belleville and Nutley) broke away from Newark. In 1839, Belleville (and what is now Nutley) separated from Bloomfield. Then in 1874, Nutley (named Franklin until 1902) separated from Belleville. The Italian American histories of Newark, Belleville, and Nutley are intertwined, yet distinctly different. Both Belleville and Nutley had neighborhoods of original Italian immigrants who settled these towns prior to 1900, and they have rich histories from the early 1900s. But many residents of Nutley and Belleville trace their ancestral roots to the original Newark immigrants as well.

Today little remains physically of Italian Newark. The Italian neighborhoods were altered in the 1950s by urban renewal and the movement of many families to the surrounding suburbs. The memory of these Newark neighborhoods remains alive in images and oral history. The churches and some Italian businesses remain. Both Belleville and Nutley, on the other hand, have retained their Italian American character. Many of Nutley's Italian Americans moved in after World War II, in the 1950s and 1960s.

The New Jersey Commission on Italian and Italian American Heritage has developed a kindergarten through grade 12 curriculum called the "Universality of Italian Heritage." The goal is to infuse this into the curriculum. New Jersey's Italian Americans in the first half of the 1900s focused on assimilation. They worked hard to learn English and sometimes spoke only English to their children. There is a renewed interest by the current generation in learning the language again and studying Italian and Italian American culture.

In 1880, there were 407 Italians in Newark. By 1920, there were 27,465 Italians in Newark, in four neighborhoods: the East Ward (now called Ironbound or "Down Neck"); Fourteenth Avenue (where many Sicilians settled); Silver Lake (northern edge, now part of Belleville);

and the First Ward (with many immigrants from Avellino). The number of Italian immigrants flowing into Newark in these years was actually much larger, but in the early years, large numbers returned to Italy or went back and forth.

Newark was a large, bustling, thriving metropolis. Much of daily life took place in part on the streets. Children played on the streets, families sat on the stoops, and mothers sat at the windows of apartment buildings to check on the children down below.

The heart of the old First Ward, the largest neighborhood, was St. Lucy's Church, which began in 1891. *Paesani* from many towns in Italy donated statues of their patron saints, most of which can still be seen: St. Vito (Castelgrande); Our Lady of Mount Carmel (Avigliano); St. Sabino (Atripalda); St. Nicolo (Teora); St. Michael (Maddaloni); St. Rocco (Lioni); Maria dell' Assunta di Pierno (San Fele); St. Sebastiano (Marigliano); and others. St. Gerard was embraced by many villages due to his work among the people during his life. St. Lucy's Church is today the National Shrine of St. Gerard Maiella.

Culture played a role in the lives of Newark Italians in the early 1900s. Newark had an opera house, where Italian opera, comedy, and dramatic theater were performed. In the 1930s, there were at least six drama companies that performed in Italian at local playhouses. There were also five radio stations broadcasting Italian programs and two Italian newspapers, and Italian films were shown. In medicine, Columbus Hospital was founded originally for the Italian community, by Louis Stefanelli, in 1921 in Newark. Columbus Hospital began as a small neighborhood facility with 45 beds and was originally named St. Gerard Hospital.

Silver Lake, originally part of Newark, was the largest and most important Italian American neighborhood in Belleville in the early 1900s. Enclaves of Italians existed throughout the town of Belleville, however. Another Italian neighborhood was the "Valley" (also called "Bondon," "good town"), located on Greylock Avenue at Roosevelt Avenue. Other enclaves of Italian families could be found on Passaic Avenue near the Nutley border, on Joralemon Street near School No. 7, and St. Mary's Place.

Even in the 1930s and 1940s, city streets still alternated with unpaved roads and farms in Belleville. In Silver Lake, occupied mostly by Italians, each house had its own little tomato patch. The occasional open lot provided space for a larger garden or for goats to graze. Many Silver Lake residents worked at several steam laundries in the neighborhood.

On the corner of Heckel and Jeraldo Streets in Silver Lake stood a small building called the West End Civic Association. Italian men and women had separate divisions, and they would raise funds for scholarships and promote common interests in the neighborhood. Members who moved to other towns would continue loyally to attend regularly scheduled meetings. The Silver Lake Fire Department was built in the 1930s in the Franklin Street section of Silver Lake, and an Italian American, Paul Zaccone, had badge No. 1. The Friendly House was a town-sponsored recreation center with a swimming pool. The building had been leased to the town by the First Italian Baptist Church. (John "Tee" Pico was a popular recreation director there for many years in his later years.)

In Silver Lake, the feast of St. Bartolomeo was celebrated in August with a procession through the streets, food and feasts, a band, and fireworks. Some people would donate huge bouquets of flowers adorned with money-covered ribbon. In the 1920s, there was a disagreement between the pastor of St. Anthony's Church and the group honoring St. Bartolomeo. Father Alessi refused to allow the statue to leave the church to be part of the procession through the streets, and to ensure that a "kidnapping" did not take place, he put the statue in jail. The procession and feast took place that year, but without the statue. According to local lore, St. Bartolomeo went into Pico's Tavern during one of the processions down Heckel Street. No one is sure if he was thirsty or sought temporary shelter from a sudden August thunderstorm.

The men's and women's societies honoring St. Bartolomeo were comprised mostly of immigrants from Cassano, Italy. In addition to the St. Bartolomeo Society, the Mother of Sorrows Society and the Holy Name Society were prominent in the early 1900s, and St. Liberatore was another saint honored with processions through the streets of Belleville.

Bordering Silver Lake was a community known as "Soho," also called Nanny Goat Hill. In 1957, Clara Maas Medical Center was relocated from Newton Street and Twelfth Avenue in Newark to Nanny Goat Hill in Belleville. Children used to pick mulberries and play at Nanny Goat Hill. On Passaic Avenue, there was also a hilly open meadow space called Nanny Goat Hill. Children used to take the family goats there to graze for the day. At the end of the day, one of the children would go get their goats and bring them home.

In the Valley neighborhood in the early 1900s, horses and wagons coming down Greylock Avenue had collided with trains, so the road was closed and a big iron fence was erected. It is said that men and women from the Valley came with picks and shovels to protest the road closing, but to no avail. During World War II, the iron was needed, so a new fence was erected and still stands today. In the 1920s, the Passaic River was dredged, and a large amount of sand was placed in the field across from Greylock Avenue. Later this became known as the "sand pit," and neighborhood children had a great time playing there.

In the 2000 census, 44.5 percent of Nutley residents reported being of Italian ancestry. Of all towns in the United States with more than 1,000 persons identifying their ancestry, Nutley ranks 12th highest for percentage of residents with Italian ancestry. From the 1920s to the 1960s, Nutley's population grew rapidly, partly due to the Italian immigrants and other Italian Americans who settled there, especially after World War II.

Nutley had three Italian neighborhoods in the early 1900s: Avondale, Big Tree, and Nanny Goat Hill (also known as "the Hill" to residents). There were some enclaves of Italians and Italian Americans in other neighborhoods as well. One of the first neighborhoods in which early Italian immigrants owned land was Nanny Goat Hill, according to an old 1900 map of Nutley. A. Pignataro, P. Sortilla, P. Massiello, and T. Grosso owned land around Milton Avenue, and P. Jannarone, J. Ferrera, and D. Ferrera also owned land in Nutley in 1900. Many of Nutley's early immigrants came from the province of Avellino (towns such as Teora) and the province of Cosenza (the town of Acri). Roma Street and Humbert Street and part of Walnut Street in Avondale were populated mainly by Italian Americans from Calabria.

Many skilled immigrants came from Italy to work in Nutley's three quarries. The quarries were important to Nutley in the late 1700s, 1800s, and just into the 1900s. The quarries were owned by Irish families (King, Phillips, and Joyce). The first quarry workers were Irish immigrants who settled in Avondale, followed by the Italian immigrants in the late 1800s. It is interesting to note that the region of Calabria in Italy also had quarries of granite and limestone. Nutley's quarries were brownstone, and much of New York City's brownstone came from the Nutley quarries. At the beginning of the 20th century, work at the quarries, as well as the mills along the Third River, may have been supporting a sizeable portion of the Italian immigrants in Nutley. The quarries closed in the early 1900s when water began seeping in, as the quarries were dug deeper, and they were no longer profitable. One of the old quarries became the Nutley Velodrome, which opened in 1933.

Avondale was home to businesses such as Viola Brothers, which started in 1912, and Ritacco's grocery store, barbershop, and tavern. Other early businesses in Nutley were Capalbo's Fruit Baskets, starting in 1906; "Mecha's" Candy Store; and Cavallo's. Zinicola's Bakery started in 1921 on Bloomfield Avenue and then moved to King Street in Big Tree. King Street used to be mostly small stores, where today there are mostly homes. There were grocery stores run by Cafones, Perrones, and Garrutos, as well as Volpe's Market.

Costello's Market was opened in 1928 by the Castellis, who raised nine children while working 18 hours a day and living above the market. At Cerami's Dairy, another family-run business, you could see the cows grazing on the farm. The pot cheese and other products were highly regarded. Antonio Cerami started the business after relocating to Nutley from Newark. His son Anthony worked in the business from the age of seven.

Much of Nanny Goat Hill and Milton Avenue was open and empty, comprised of gardens and vineyards even through the 1950s and early 1960s. Most of the families had large gardens, although homes were modest by today's standards. In the Ruffo family, for example, the parents,

seven children, and their grandfather lived in a two-room home, with a small anteroom and a basement for winemaking. The home was built in the late 1800s. There was a hand-pump well in the back of the house and an outdoor brick oven to bake bread. There was an outdoor stove, to do the canning of the peppers, corn, tomatoes, and peaches. They made jellies, and there was a small shed to store tools. The garden had tomato plants, in addition to other vegetables, and was right next to the 200 chickens and the pigeons. There were many grapevines, and people used to come from New York to pick the grapes there. Winemaking and storing took place in the basement, where the grapes were pressed, and all the children would help.

The families on Milton Avenue had large gardens, and people also kept goats and roosters and rabbits. There were fig trees that had to be wrapped in the winter to protect them from the cold. Gradually more and more houses began to be built on Milton Avenue, as children grew up and started families of their own, but the large gardens remained.

Newark area Italian Americans have achieved success in medicine, politics, science, and other professions. Most well known may be the musicians and actors who grew up in the 1930s, 1940s, and 1950s, including Connie Francis, Joe Pesci, and Frank Langella, among others. Frankie Valli and the original Four Seasons performed in local Belleville and Newark clubs as the Variatones until they became the Four Lovers. Their early lives are portrayed in the award-winning Broadway musical *Jersey Boys*. Celentano's frozen foods began in a delicatessen in Newark with Dominick Celentano's homemade ravioli. Frank Sinatra grew up in Hoboken, but he ordered bread shipped to him wherever he was performing from Giordano's Italian Bakery on 33 Seventh Avenue in Newark. It is said that his favorites were the medium panelle and the bastone bread, made with pepperoni, salami, and mozzarella. Although many celebrities did grow up in Italian Newark, Belleville, and Nutley, these pages portray the images of the ordinary, hardworking Italians who achieved fame and fortune in their own way, in a new land. This is their story.

One

NEWARK

By 1920, the four Italian neighborhoods—Ironbound (known then as the East Ward), Fourteenth Avenue, Silver Lake, and the First Ward—were well established. Housing in these neighborhoods was mainly multiple-story tenements, although some elegant homes existed in the Forest Hill section. Newark was a large, bustling, thriving urban metropolis. Much of daily life took place in part on the streets. Children played on the streets, families sat on the stoops, mothers sat at the windows of apartment buildings to check on the children down below, and all types of goods were sold on the streets. Even the "Sweet Potato Man" is a fond memory.

Much has been written about Newark's First Ward, which was by far the largest of Newark's Italian neighborhoods. St. Lucy's Church was its heart. The founder of Newark's First Ward southern Italian community was Angelo Maria Mattia, in 1873. He was a woodcutter in New York City who one day took a ferry by accident across the Hudson River. He found work in Newark with some Genovese families already living there, and he established a colony of southern Italians. Mattia was born in Calabritto, and his sister was married to a man from Caposele. That is how others from these towns came to settle in the old First Ward.

River Street, between Mulberry Street and McCarter Highway, was the center of the second Italian neighborhood in old Newark. The River Street colony flourished and soon flowed into Ironbound, or "Down Neck." By 1900, Italians from Calabria lived on Ferry Street and filled the many side streets. The Our Lady of Mount Carmel Church building, purchased around 1900, had originally been a Protestant church. Ironbound had many Polish, Irish, and other immigrants, as well as Italian immigrants. It is remembered as a multiethnic neighborhood where everyone got along, yet cultural traditions were maintained.

About the same time, Newark's Fourteenth Avenue Italian neighborhood was growing along Fourteenth Avenue and the adjoining streets. This area was settled originally by Sicilians, immigrants from provinces south of Naples, and many families from the First Ward who also moved there. By 1901, this Italian neighborhood was large enough to build St. Rocco's Church on the corner of Fourteenth Avenue and Hunterdon Street. St. Rocco's Drum and Bugle Corps was highly regarded and performed at the many parades and religious processions.

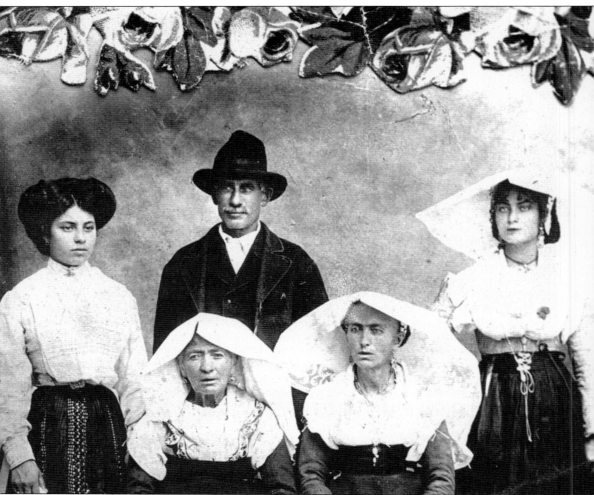

Families were resilient and remained close, despite the challenges of immigration and family separations. They kept in touch by letter and by sending photographs. This is the Manna family in the typical folk costumes of Boiano, southern Italy, about 1910. Young Clorinda Manna (standing on the right) immigrated to the United States shortly after this photograph was taken. It is likely that her mother and grandmother (sitting), and father (standing) are also present in the photograph. The identity of the other young woman is unknown. Clorinda's older sister, Maria Manna (not shown), had immigrated to America in 1904 at the age of 19. She had $10 with her, and she went to stay with her brother Antonio. She married Fiorangelo (Frank) Biondi (next page), who had emigrated in 1893 at age 16. He listed his occupation as "laborer." They had six children before Maria died at age 31 of pneumonia. An infant child had to be sent to a wet nurse. (Courtesy Deanna Hohmann.)

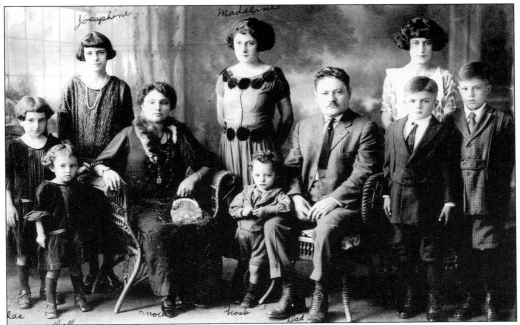

Fiorangelo (Frank) and Columbia (Melillo) Biondi, of Sixth Avenue in Newark, pose with their eight children around 1923. Biondi's first wife, Maria Manna, died, leaving six children. Biondi then married Columbia and had two more children. Later in life, Frank and Columbia lived on Parker Street in Newark. They made wine and vinegar from grapes purchased right off the freight car, and the family ran a butcher shop. (Courtesy Deanna Hohmann.)

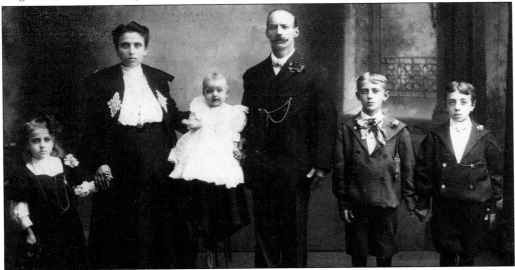

Francesco Antonio Guarino came from Teora, Italy, to Newark in 1885. He returned to Italy and married Silvia De Nicola from Calabritto (Avellino). His first three children were born in Calabritto. He returned to America in 1901 and was followed by his wife and three children the following year. Although he was a carpenter by trade, like all the men in his family in Italy, he opened a pharmacy in Newark, Guarino's, on First Avenue at Bloomfield Avenue. The Guarino family poses here in 1905. (Courtesy John Rendfrey.)

13

In the early 1920s, Maria Josephine Grasso from Teora, Avellino, Italy, is shown here in Teora with some of her children. Maria's oldest son, Peter (not shown), traveled to America at age 14 and settled in Newark. He eventually joined the U.S. Army in World War I. Peter was wounded and honored by the U.S. government. He later owned a jewelry store in Nutley. Peter never knew his siblings in this photograph, because he immigrated to the United States before they were born. (Courtesy Michael Vargas.)

Mary (Grasso) Zelanti was two years old in 1932. She and her brother Paul Grasso were the children of Peter Grasso, who emigrated from Teora in 1914 at the age of 14 (his mother can be seen above). Mary grew up in the Roosevelt area of Newark. Eventually the family moved to the North Ward (North Sixth Street). Mary went to St. Francis Xavier Elementary School. In 1952, she married Anthony Zelanti. They had three children and lived in the North Ward until 1995. Mary worked as a beauty school teacher. (Courtesy Michael Vargas.)

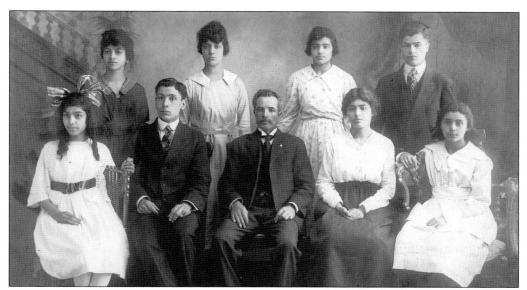

Antonio Tronolone, widowed father of eight Tronolone children, poses here with his children, two sons and six daughters, around 1915. Josephine (left, rear) and Andrew (right, rear) served with U.S. forces during World War I. Josephine was a nurse; Andrew was an enlisted man. They were able to meet each other in France during the war. Antonio emigrated from San Fele, Italy, about 1885. He married in 1890 and then worked variously as a saloon keeper, bootblack, and factory worker supporting his eight children. They lived on Nuttman Street in Newark. (Courtesy Richard Cummings.)

Mary Tronolone, around 1915, was the oldest daughter in the family of Rose and Antonio Tronolone (above). She was a seamstress and helped support the family after their mother died. The family lived on Nuttman Street, behind what is now New Jersey Institute of Technology, near the Warren Street School. In 1920, they moved to 195 North Fifth Street, in the St. Rose of Lima Parish, Orange Street, Newark. (Courtesy Richard Cummings.)

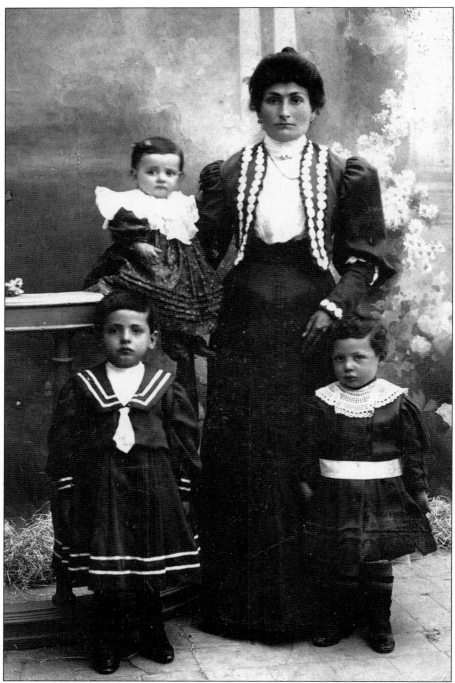

Aquilia Baldaccini from Foligno, Umbria, poses in this c. 1908 photograph with three of her six children, Dalida (later known as "Dolly"), Louis, and Angelo. At first, the family settled "Down Neck," then moved to North Newark, on Parker Street. Dalida later married Ulisse Senerchia, a musician and concert pianist who is pictured on the adjoining page. (Ulisse had emigrated from Foggia, Italy, with his family.) (Courtesy Elissa Senerchia.)

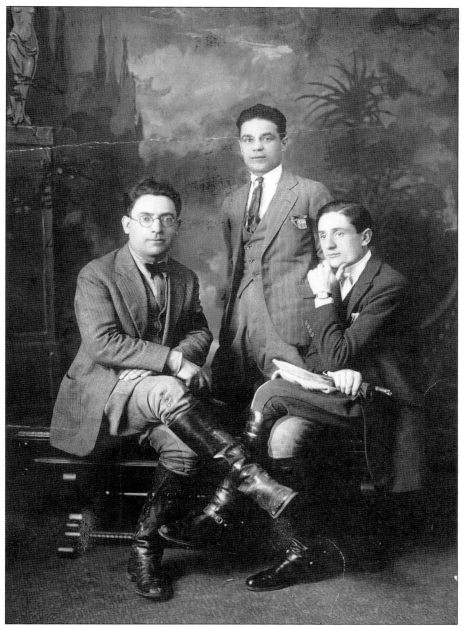

Ralph, Ulisse, and Herman Gildo Senerchia pose for this *c.* 1920 portrait. The Senerchia brothers, like their father and his father in Italy, were all musicians. Ralph was a concert violinist; Herman Gildo was a flutist; and Ulisse was a concert pianist. Their father, Emanuel Senerchia, with his wife, Carmela Roberto, came from Panni, Foggia, Italy, in 1896, settling in Newark as a music teacher. Emanuel was an accomplished pianist and composer. His son, Ulisse, came to Newark in 1903, when he was 11 years old. Ulisse had studied music in Europe and gave concerts in various parts of the state. Ulisse is credited with introducing to the Italian colony of Newark the music of Chopin, Beethoven, and Bach. Ulisse was fond of horseback riding, and the three brothers here appear to be in their riding outfits. (Courtesy Elissa Senerchia.)

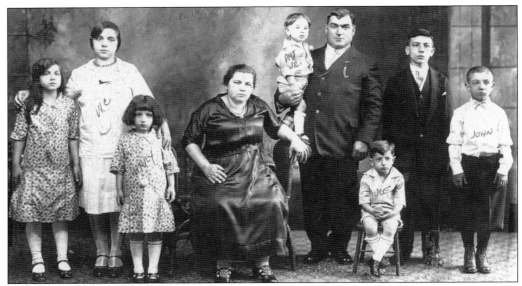

The Fresolone family lived on Nichols Street, Down Neck in Newark. Seen here in this c. 1927 photograph are, from left to right, Rose, Vicky, Mary, Elisabetta (nee D'Angelo), Pat Jr., Pasquale ("Pat"), Joseph, George, and John Fresolone. Pasquale had a merry-go-round truck in the 1920s, powered by a hand crank, for six or eight children. Pasquale's son George would crank the machine. Children ran to greet the truck. Rides cost a penny, but on some days the children were given free rides. (Courtesy Steven Mairella.)

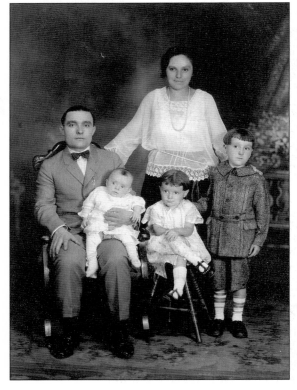

Donato (Dan) Perillo, and his wife, Millie Ventre Perillo, pose with their three children, Fay (being held), Erma, and Frank, around 1924. Donato was born in Forenza, and Millie was born in Caposele. Donato owned a grocery store. (Courtesy John Rendfrey.)

18

Here around 1925, one can see Vincent (Vincenzo) Messina, a barber, who was born 1892 and came to Newark at age 18. He married Catherine D'Antoni (see page 36) in 1926 at Santa Ninfa, province of Trapani, Sicily. They had three children, Margaret, Ninfina, and Antoinette. (Courtesy Antoinette J. Messina-Pagano.)

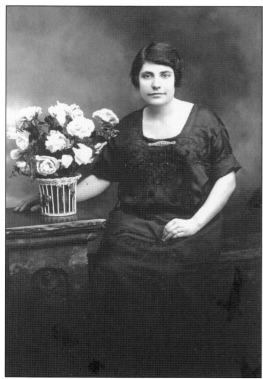

In 1909, Concetta Amato, born 1889 in Caserta, married Giacomo (James) Fazzone, born 1884 in Foggia. Like so many, she made pasta from scratch at home. She was always wearing an apron and usually cooking something. Giacomo was employed as an eraser pressman (factory worker) for the Eberhardt Faber Rubber Company, which produced pencils and erasers. With his grandchildren, he had a neat trick of folding a hankie into a "rabbit" and making it jump from his hand when he stroked it. (Courtesy James Caboy.)

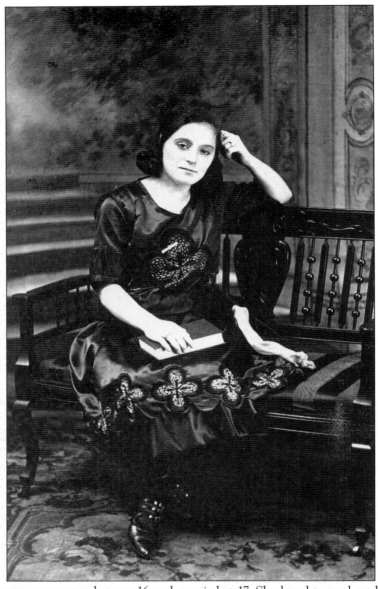

Elizabeth Ventre was engaged at age 16 and married at 17. She loved to read, and the book in her hand can be seen in this 1920 photograph marking her engagement. Her mother, Raffaela (Sturchio) Ventre, could not read or write, but she taught even her great-grandchild about St. Gerard, using the photographs in a book from Italy about the life of St. Gerard. Elizabeth had red hair and did not look "Italian." In school, her name was changed by her teacher to "Elizabeth Vandere." Even her parents signed the name "Vandere" on the old report card. Elizabeth wanted to be a schoolteacher. She went to school at night. For the first week, her father, Antonio, followed her to school to make sure she would be ok. When Elizabeth married Enrico Stefanelli (see page 4), an Italian immigrant, she lost her citizenship, even though she was born in the United States. At that time, under the law, if one married a noncitizen, one lost their citizenship. She had to go through the naturalization process later in life to become a citizen again. (Courtesy John Rendfrey.)

Antonio Russomanno arrived in America in 1920, leaving his sweetheart Gerardina Farina back in Caposele, in the province of Avellino, where they were both born in 1903. He sent her romantic postcards and letters and studio portraits, such as this one, during the two years that they were separated. She came over in 1922, and they were later married at St. Lucy's Church in 1929. He made his living as a tailor, and she worked briefly in a handkerchief factory. They had three children. (Courtesy Susan Berman.)

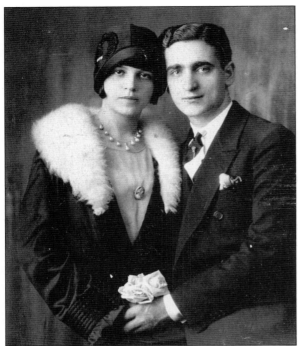

In 1927, Catherine Nanariello and Michael Calabrese, children of immigrants from Bari (Apulia), pose before their marriage. Michael learned to be a barber when his father opened the Whiteway Barbershop at 85 Thirteenth Avenue. Catherine worked on men's straw hats. They met when Michael shyly peeked through the boxes at the hat factory on Carter Highway where they both worked. She later went to New York City to design hats. (Courtesy Lilian Vizusso.)

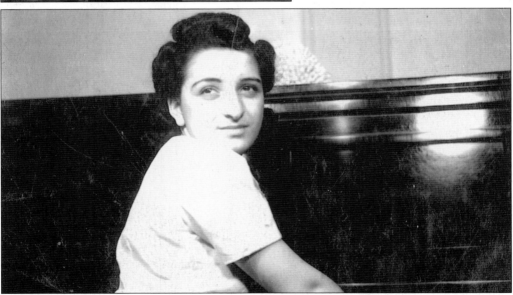

Connie Malvaso sits at the family piano at their home on Vermont Avenue in the Vailsburg section of Newark, 1935. She learned to play by ear. The family also had an old-fashioned player piano. Growing up, she and her sisters would entertain themselves by playing songs and singing tunes they knew. She was a singer, pianist, actress, and linguist in her teens and early 20s, and she spoke five languages fluently. Connie married Andrew Salvatore Garofalo, a child of immigrants from Montella, Avellino. There are many other Salvatores in that town because during a drought St. Salvatore himself appeared and told the townsfolk where to dig for a well. They did and they were saved, so many named their sons Salvatore. (Courtesy Francine Aster.)

Leah Fusco and Salvatore Fusco, her grandfather, pose here in the early 1900s. Salvatore emigrated from Benevento, in the 1890s. He lived first at 29 Webster Street in the old First Ward and later (1950s) purchased a three-family home and converted it to a six-family home at 359 Clifton Avenue. The home had parquet floors, chandeliers, and beautiful oak woodwork and doors. (Courtesy Lester Fusco.)

23

Salvatore Fiducia holds his son, Fred Fiducia, who later became a well-known boxing champion in Newark. Salvatore came to New York City from Sicily in 1897. He was a puppeteer with a little traveling marionette theater on the streets of New York. He saved enough money to send for his intended bride, Angela Giacone, the next year. They married in 1898, moved to Newark, and opened the Fiducia Macaroni Factory around 1905 at 69 Madison Street. Salvatore and Angela lived upstairs and got up at 3:00 every morning to make the pasta. Customers came from New York and Brooklyn by train or carriage to buy a month's supply of macaroni. They eventually purchased their three-story building, raised eight children there, had the first player piano on the block, and would dress up elegantly and go by horse and carriage to the opera in New York every couple of months. (Courtesy Maryann Leo.)

Gerardo Spatola Sr. started the Spatola tradition of donating Easter baskets for the poor. This group, with Gerardo Spatola Jr. and Tony Galento (the fighter), gathers in front of Vittorio Castle, around the 1940s. Joe DiMaggio was often a guest of Jerry Spatola at Vittorio Castle. The Spatola family was involved in many community works. In addition to the funeral home, Gerardo Jr. chaired the Newark Planning Board in the 1940s, and he was a commissioner for the Newark Housing Authority. (Courtesy Spatola family.)

In 1903, Gerardo Spatola Sr. holds the newly born Gerardo (Jerry) Spatola Jr. This may have been a christening. (Courtesy Spatola family.)

This is a graduation photograph at Webster School, around 1917. Gerardo Jr. is shown far left, front row. Notice the girls' white dresses and hair bows and the boys' knickers and long jackets. (Courtesy Spatola family.)

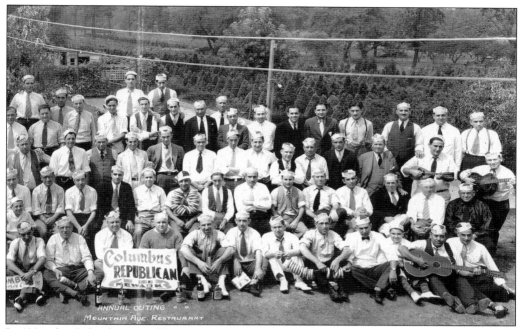

In 1934, the Columbus Republicans of Newark had their annual outing at the Mountain Avenue Restaurant in Springfield, New Jersey. Gerardo Jr. (on the left behind the banner) was the president for many years. Notice mandolins and guitars on the right side. (Courtesy Spatola family.)

Bina and Geta Spatola stand in the backyard of their home on North Seventh Street in Newark, around 1930. Rose Spatola, their mother, made the dresses. A few years later, the two young sisters started a fan club for Frank Sinatra called the Sighing Society of Sinatra Swooners. It was the first national fan club for Frank Sinatra and had over 3,000 members. (Courtesy Spatola family.)

Joseph Viviani, at 384 South Nineteenth Street, is shown here upon returning from boot camp in the U.S. Marines in 1951. The Viviani family had a beautiful family home in Forest Hill, at 245 Montclair Avenue. The extended family and grandparents, Ignazio and Josephine Viviani, lived on the three floors. But the family lost almost everything in the crash of 1929, and the house was damaged while they were attending a family wake, staying over at the relatives' home, as was the custom. (Courtesy Joseph Viviani.)

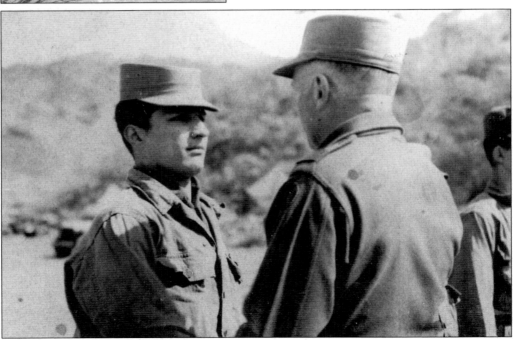

Pvt. Gaetano Nicastro receives an award from Major General Trudeau in 1953. He served as a medic in the army and was stationed in Korea during the Korean conflict. He received the Purple Heart and the Bronze Star. (Courtesy Rev. Thomas D. Nicastro.)

Thomas Ruggiero was a paratrooper with the 101st Airborne Division. He trained at Fort Benning, Georgia. This photograph was taken in Branch Brook Park, about 1942. He went to France and died on D-Day, 1944. His parents came from Moiano, Benevento, Italy. The family lived at 5 Drift Street in Newark. It was a five-story walk-up building. In 1945, the High Street Pleasure Club held a dinner dance and honored the local war heroes on the front page of the program. (Courtesy Marie Solimo.)

Claire Fusco, a WAVE (Women Accepted for Volunteer Emergency Service) in World War II, stands with her nephew and niece, Lester Fusco Jr. and Linda Fusco, around 1946. Claire gave Lester an aviator scarf that was 15 feet long, which she received from a navy air force pilot. Lester still has the scarf. Lester and Linda were born and raised at 29 Webster Street in the old First Ward. Later (1950s) the family lived at 359 Clifton Avenue. (Courtesy Lester Fusco.)

Frances Caruso, around 1940, was in the WACs (Women's Army Corps). Her parents, who met in America, were Lorenzo and Rachela Caruso. Her mother was born in 1878 and arrived in Newark about 1896. Frances Caruso was the sister of Catherine Caruso Coppola, and the aunt of Gerald Coppola (see next page). (Courtesy Marianne Coppola.)

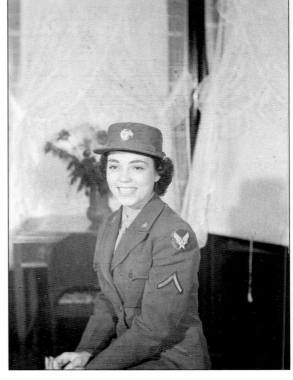

In 1945, Michael A. Bravette holds cousins Frankie and Pattie Bravette, standing on the steps at 80 Hoyt Street in Newark. Michael sailed on the USS *Bremerton*, flagship of the 7th fleet, Asiatic Pacific Theater. The house at 80 Hoyt Street was a six-family house owned by Michael's great-grandmother Filomena Bianco, born in 1844 and died in 1946. Michael is the son of Patrick and Philomena "Mamie" (Bianco) Bravette. (Courtesy Michael A. Bravette.)

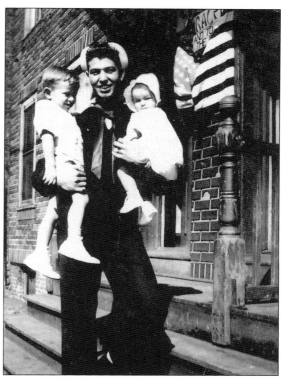

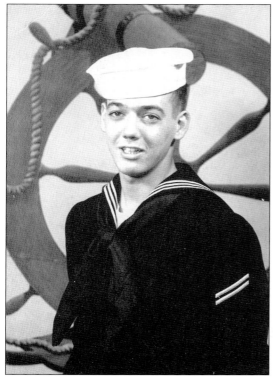

Gerald Coppola was in the U.S. Navy in this photograph taken about 1956. Coppola's parents were Alfred Coppola Sr. and Catherine (Caruso) Coppola, and he grew up on South Fourteenth Street and on South Ninth Street. His paternal grandparents were Luigi and Theresa Coppola, who came over from the Naples area in the early 1900s. Theresa was 18 when she came over. Luigi was a bricklayer, it is believed, for the Sacred Heart Cathedral construction. (Courtesy Marianne Coppola.)

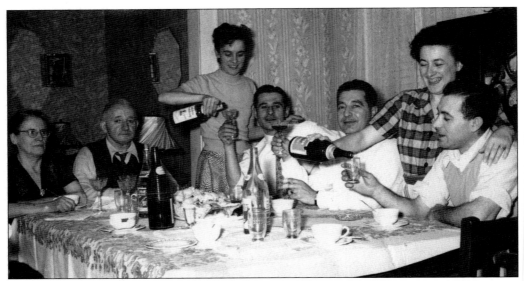

Parties were frequent and often marked family events. This was a holiday party in 1955 between Christmas and the New Year. Seated are Maria and Domenico Tibaldo (at the left) and other extended family members. Domenico had emigrated from Montorso, in the Veneto region, to the United States in 1908 at age 19. He worked in the mines and served in World War I, qualifying for U.S. citizenship. He married in Italy, and his wife Maria immigrated to America in 1936 with their three children. The family eventually settled on Tiffany Boulevard in Newark, where other northern Italians also lived. (Courtesy Marylou Tibaldo-Bongiorno.)

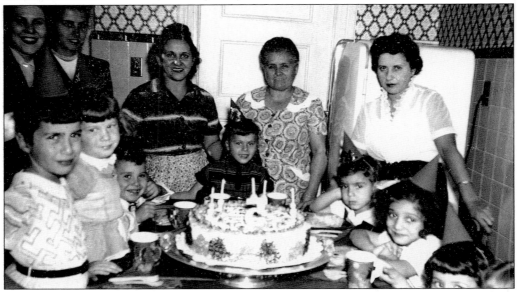

In this 1953 photograph, the fifth birthday of Marianne Pepe is celebrated in her grandmother's (Philomena Sperduto, second from right) apartment at 80 North Seventh Street. Her parents lived on the second floor, but to avoid having children run up and down the stairs, the party was held on the first floor. One can see that the cake was huge, and Marianne was wearing her favorite dress. Attendees are members of the Pepe, Nazaretta, Abruzzese, Casale, Barbier, and Monticello families. (Courtesy Marianne Pepe Murray.)

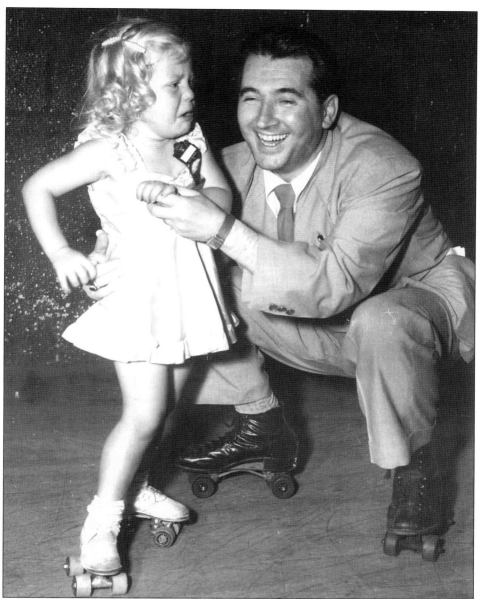

This photograph of Peter Rodino on roller skates is probably from the late 1940s. The child is unidentified. Born Pellegrino Rodino in Newark in 1909, he was the son of an Italian immigrant carpenter. He graduated from Barringer High School, then worked at menial jobs for 10 years and studied at night to obtain a law degree at the New Jersey Law School. During World War II, he served in Italy and North Africa. He was elected to Congress in 1948 as a Democrat, and he was reelected for 19 terms, until his retirement in 1988. In Congress, he was one of the main sponsors of the Civil Rights Act of 1964 and the Voting Rights Act of 1965. Rodino chaired the Judiciary Committee and thus presided over the impeachment proceedings against former president Richard Nixon in 1974. After retiring from Congress, Rodino taught at Seton Hall University Law School until his death in 2005. (Courtesy Peter W. Rodino Jr. Papers, Seton Hall University School of Law.)

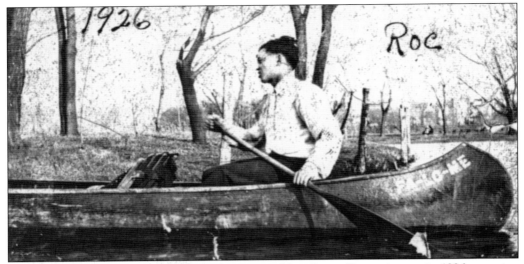

Branch Brook Park was a favorite spot for outings. Here Rocco Raimo is seen in 1926 canoeing on Branch Brook Lake, near Lake Street, in a canoe named *Fa-lo-me*. There was a beautiful boathouse and ice-skating on the lake in the winter. Or one could just sit and read a book. (Courtesy Angela M. Raimo.)

Many families spent Sunday afternoon in Branch Brook Park, now on the border of Newark and Belleville. Then and now, the park was famous for its magnificent cherry blossom display, seen in this photograph from 1942, with the Raimo family, Rocco, Theresa, Al, and Angela. (Courtesy Angela M. Raimo.)

At Union Beach ("Charlie's Beach") in 1948, Connie Malvaso, a girlfriend Mary, and Kay and Nancy Malvaso mug for the camera. The Malvaso sisters all spoke Italian as their first language. They were the children of Felicia Neri and Francesco Malvaso, immigrants from the town of Vibo Marino, Reggio Calabria, in southern Italy. Felicia and Francesco met on the boat when immigrating to America, and they married in Newark. (Courtesy Francine Aster.)

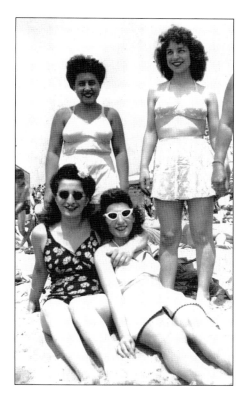

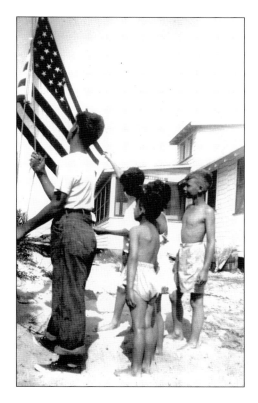

In 1949 at Reed's Beach, cousins raise the flag outside their cottage, a morning ritual that took place every day. David De Carlo and Al Raimo unfurl the flag, while Robert De Carlo, Angela Raimo (hidden), and William De Carlo look on. (Courtesy Angela M. Raimo.)

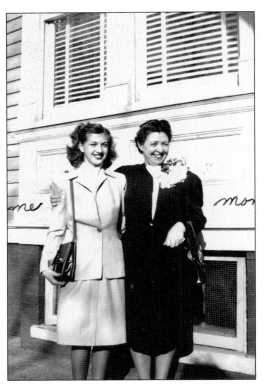

On Easter Sunday of 1947, Antoinette J. Messina and her mother, Catherine D'Antoni Messina, pose on South Twentieth Street in Newark, in the West Side High School area. Catherine was born in 1904 at Santa Ninfa in the province of Trapani, Sicily. She married Vincent Messina in 1926 in Sicily. (Courtesy Antoinette J. Messina-Pagano.)

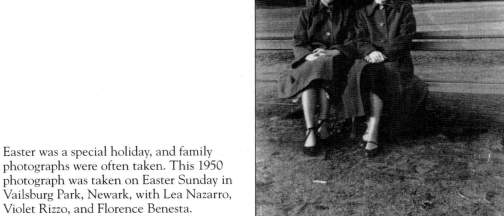

Easter was a special holiday, and family photographs were often taken. This 1950 photograph was taken on Easter Sunday in Vailsburg Park, Newark, with Lea Nazarro, Violet Rizzo, and Florence Benesta. (Courtesy Florence Benesta.)

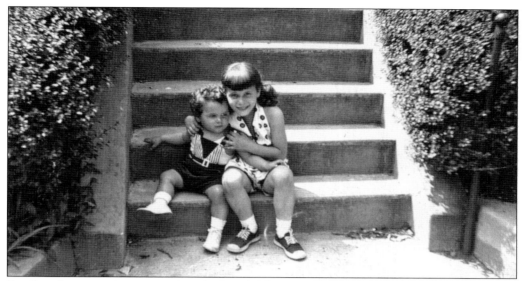

Family values were important. As a little girl, Marianne Pepe was at first not pleased with her baby brother Anthony, because she had requested a baby sister. Her mother let her hold the new baby and told her that he needed a big sister. When she held Anthony in her arms, he became her beloved baby brother, part of the family, and they were always close. (Courtesy Marianne Pepe Murray.)

This is the door to the winemaking cellar at 80 North Seventh Street, where grapes were delivered. Angelo Maria Sperduto (from Teora 1910) ordered grapes every autumn from the farmers' market. He made 16 barrels of red and white wine. Once the grapes had been pressed, they were left to ferment in the barrels, and the aroma could be smelled everywhere. Each night immediately after dinner, he would go to the basement and gently pick up the lids of the barrels to listen to the sound of the fermentation taking place. When relatives and friends of the family would visit, all were given a bottle of wine to take home. (Courtesy Marianne Pepe Murray.)

This little boy (Emanuel Alfano) had long hair until the age of four. At that time, he asked his landlord to cut his hair. He was taken to a barber, and the boy asked the barber to save his hair for his mother, Maria Ditta Alfano (who came about age 19 from Vita, Sicily). They lived at 269 Fairmount Avenue. (Courtesy Emanuele Alfano.)

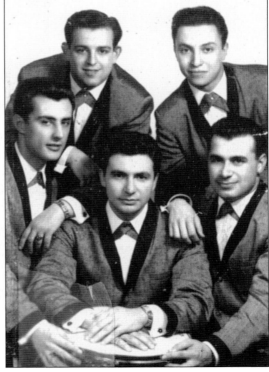

Frankie Valli and the Four Seasons started out in local Newark and Belleville clubs. In this delightful 1958 photograph, one can see the Preludes posing in high school. Pictured are, clockwise from top left, Gene Antonio, Tony Freda, Ralph Conti, Emanuele Alfano, and Charles Sousa. (Courtesy Emanuele Alfano.)

"Sweater clubs" or "jacket clubs" were popular. In this *c.* 1930 photograph, the Silver Kings, Rocco Raimo, Nick Briante, and Pat Briante, can be seen. Notice the names embroidered on the jackets. Clubs were also popular for girls. For example, at West Side High School in the 1950s, there was a group of young ladies called the Vignettes. They also had jackets with individual names embroidered on them. (Courtesy Angela M. Raimo.)

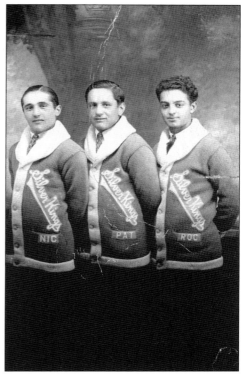

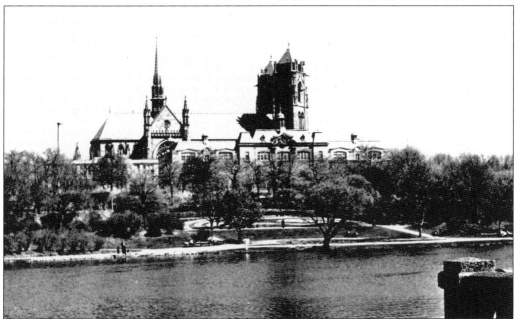

This is a photograph of Barringer High School, probably from the 1930s. Notice the circular landscaped area in the front and Sacred Heart Cathedral looming just across from the high school. Barringer High School, founded in 1838, is the third-oldest public high school in the United States and the oldest in New Jersey. (Courtesy Lilian Vizusso.)

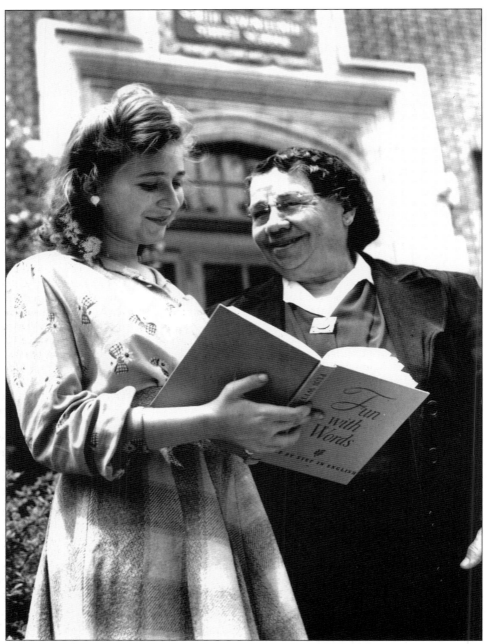

Concetta Stefanelli Montone, on the right, went back to school at age 57 to learn to read. She graduated from Seventeenth Avenue Grammar School and is shown here with one of her teachers. Concetta was born in Teora. Like most women at that time, she received no schooling. She arrived in Newark in 1889 with her brother and his family. She married Joseph Montone, who was a well-known bootblack on Market Street in Newark. Concetta decided to go to school because one day she asked a bus driver if his bus went to Nutley. He said "Wassa matter? Cantcha read?" That made her mad, and she decided to go to school to learn to read. The year of this photograph is 1944. (Courtesy John Rendfrey.)

Two

BELLEVILLE

Heckel Street in Silver Lake had many businesses, including two macaroni factories, Davella's and Fiscella's, and the Bonavita Bakery. Mrs. Bonavita made cookies and cakes for weddings, and her biscotti were legend. Like many businesses, Pico's Tavern, run by Giovanni Pico and Rosina (DeBlasio) Pico, was also the family home. Pico's Tavern was a hub of activity and a sort of "Italian consulate" in Silver Lake. Rosina Pico had just a basic education, but she would help others to write or read letters to and from Italy or to learn how to send money. Pico's Tavern was known in Cassano, Italy, as the "Rosina di Faccibella Bar." *Faccibella* means "beautiful face," and this had been the nickname given in Italy to Rosina's mother, Carolina (Marino) De Blasio.

There were also Italian-owned businesses on Joralemon Street near School No. 7, as well as further down on Passaic Avenue near the Nutley border. Angelo Calicchio had a barbershop on Joralemon Street in the 1930s. Nick Merola, from one of the two family homes on Jefferson Street, worked for Calicchio and eventually took over. Nick's niece Rosebud and her husband, Charlie Raphael, had a candy store and luncheonette that was adjacent to Merola's family grocery store. Originally named the BelSpa, everyone called the candy store Rosebud's, because Rosebud was so kind to all the kids who gathered there. Kids from School No. 7 whose mothers worked even had their lunches there until it was time to go back to school.

Some of the other families who lived or had businesses and farms on Passaic Avenue were Lombardi, Lugano, Scarpelli, Nicolette, and Lupo, to name a few. The Vuonos had a market, the Avallones owned a tavern, and the Zoppis owned a brick apartment building. Popular names from Heckel Street included Bocchino, Barbone, Labadia, Miele, Schiavo, Corbo, Marra, Mobilio, Christiano, DellaTerza, and Quaresimo. The Vernieros were early settlers who purchased property on Wallace Street in 1889. Family members still own that home today.

The Valley was another Italian enclave in Belleville with a tightly knit community. In addition to the ubiquitous garden, chickens might be raised in the backyard, and at least one home on Greylock Avenue had its furnace on the first floor, because the cellar was used for making and storing wine.

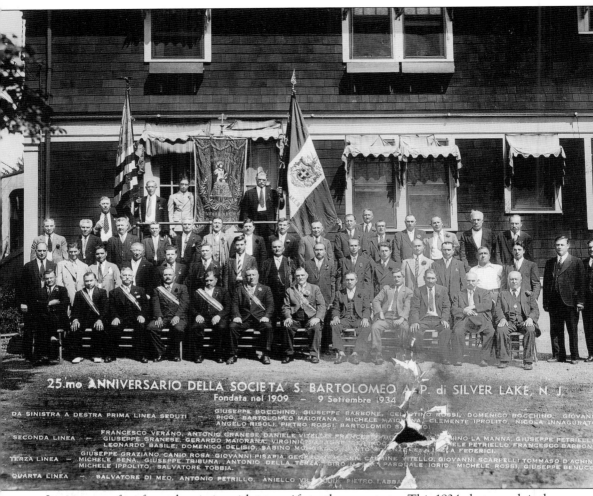

25.mo ANNIVERSARIO DELLA SOCIETA' S. BARTOLOMEO A. P. di SILVER LAKE, N. J.
Fondata nel 1909 — 9 Settembre 1934

DA SINISTRA A DESTRA PRIMA LINEA SEDUTI — GIUSEPPE BOCCHINO, GIUSEPPE BARBONE, CELESTINO ROSSI, DOMENICO BOCCHINO, GIOVANNI PICO, BARTOLOMEO MAIORANA, MICHELE MAIORANA, CLEMENTE IPROLITO, NICOLA INNAGURATO, ANGELO RISOLI, PIETRO ROSSI, BARTOLOMEO SENA.

SECONDA LINEA — FRANCESCO VERANO, ANTONIO GRANESE, DANIELE VITILLO, FRANCESCO ...NO LA MANNA, GIUSEPPE PETRILLO, GIUSEPPE GRANESE, GERARDO MAIORANA, VIRGINIO ... ELE PETRIELLO, FRANCESCO BARBONE, LEONARDO BASILE, DOMENICO DELISIO, SABINO MONG... ...A FEDERICI.

TERZA LINEA — GIUSEPPE GRAZIANO, CANIO ROSA, GIOVANNI PISAPIA, GE... ...A CARMINE VITELLO, GIOVANNI SCARPELLI TOMMASO D'ACHINO MICHELE SENA, GIUSEPPE TRIBUNA, ANTONIO DELLA TERZA, GIRO M... ...PASQUALE IORIO, MICHELE ROSSI, GIUSEPPE BENUCCI, MICHELE IPPOLITO, SALVATORE TOBBIA.

QUARTA LINEA — SALVATORE DI MEO, ANTONIO PETRILLO, ANIELLO VI... ...PIETRO LABBA...

Immigrants often formed societies with *paesani* from the same town. This 1934 photograph is the Societa Cassanese di San Bartolomeo, founded in Silver Lake in 1909, with members from the town of Cassano. Giovanni Pico was the president for many years. When he was too old to walk in the St. Bartholomew processions, the police carried him along in a sidecar of the motorcycle. Pico was buried with the official sash from the society, normally worn by the president at the procession each year. For several years thereafter, the president's sash was missing because it had been buried with Pico and not replaced. Giovanni and Rosina DiBlasio Pico emigrated from Cassano about 1892, then moved to Belleville and purchased or built Pico's Tavern at 91 Heckel Street in the early 1900s. They lived next door and raised eight children. Some of the names listed at the bottom include Federici, Delisio, Innagurato, La Manna, Bocchino, Barbone, Risoli, Rossi, Basile, Verano, Granese, Iorio, D'Achino, Benucci, Petrillo, Tobbia, Di Meo, Graziano, Rosa, Tribuna, Ippolito, and Petriello. (Courtesy Paula Zaccone.)

Pico's Tavern, at 91 Heckel Street, was a center of the Silver Lake Italian community. Around 1950, Arthur Pico, youngest son of Giovanni and Rosina Pico, is shown here. He was a teacher, assistant superintendent of schools, and principal of Schools Nos. 2, 8, and 10. School No. 8 was later named after him. (Courtesy Paula Zaccone.)

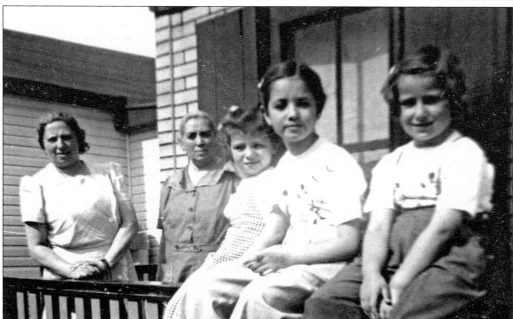

The extended Pico and Zaccone families went to a bungalow at Broad Channel on Jamaica Bay, New York, each summer. Concetta Pico and Rosina DiBlasio Pico and her three grandchildren, Paula Zaccone, Carol Anne Zaccone-Flinn, and Roseann Pico Valerian, appear here about 1949. (Courtesy Paula Zaccone.)

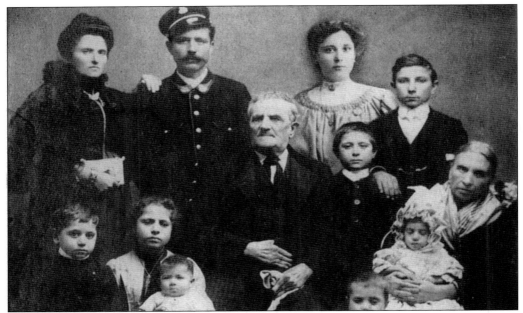

Filomena Velardi Calicchio, her husband, Giovanni Calicchio (in the Italian train conductor uniform), and children appear in a photograph taken in Benevento, Italy, with the groom's parents, around 1900. One of the children is Angelo Calicchio. Filomena immigrated after her husband died. She had brothers who were cabinetmakers in Newark. Instead of a pension, the Italian government gave her a government store to run, but she decided to immigrate. She and her children settled in the First Ward, and they found work in the factories of Newark. (Courtesy Phyllis Marie Cupparo.)

Angelo Calicchio, son of Filomena (above), holds his daughter, Phyllis Calicchio Cupparo around 1917. Angelo had married Rosa Lombardi after they met at the Clark Thread Factory where they both worked. Rosa was born here but had to give up her citizenship when she married Angelo, an immigrant—the law at that time. (Courtesy Phyllis Marie Cupparo.)

Phyllis Calicchio Cupparo (from the facing page) is the bride coming out of her family's home on 500 Joralemon Street (next to School No. 7, where she taught) on the day of her wedding to Dante Cupparo 1943. Also in the photograph are her younger sister, Marie Calicchio Kenny, her maid of honor; her father, Angelo Calicchio; and Margaret Tedesco, a family friend. (Courtesy Phyllis Marie Cupparo.)

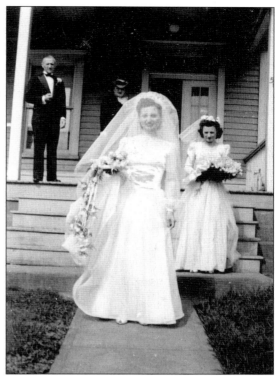

School No. 7, at Joralemon Street and Passaic Avenue, was the center of an Italian neighborhood in Belleville. Passaic Avenue had originally been Italian farms and businesses, and an enclave of Italian immigrants lived there. Phyllis Marie Cupparo is in the baby carriage in front of the school in 1947. The family home was right next to the school, and Phyllis's mother, Phyllis Calicchio Cupparo (above), taught at the school. As a child, she used to watch her mother bring the schoolchildren outside to play. (Courtesy Phyllis Marie Cupparo.)

The Valley neighborhood, Greylock and Roosevelt Avenues, was settled early by Italian immigrants. Around 1918, Pietro Duca is shown on Roosevelt Avenue. Pietro and Cecelia Policastro Duca emigrated from San Gregorio Magno in 1894, when they were 41 and 37 years old. They went first to Newark, where Pietro and his young sons serviced and lit the gas lamps. About 1912 they came to the Valley, where Pietro bought property and built two homes. (Courtesy Nicholas Duca Jr.).

Seen around 1920, this is the back of a home near 38 Greylock Avenue in the Valley section of Belleville. Notice the farm wagons and implements and open field visible to the right of the home. This may be a family that had recently arrived from Italy. (Courtesy Anne Colon.)

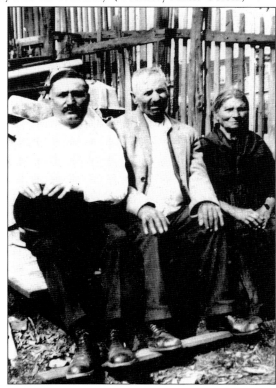

This picture was taken in the early 1930s on Roosevelt Avenue. Shown are Cecelia Policastro Duca and her brothers Tony and George Policastro. Cecelia and her husband Pietro Duca had a total of 17 children. Only 4 survived to live in the United States. (Courtesy Nicholas Duca Jr.)

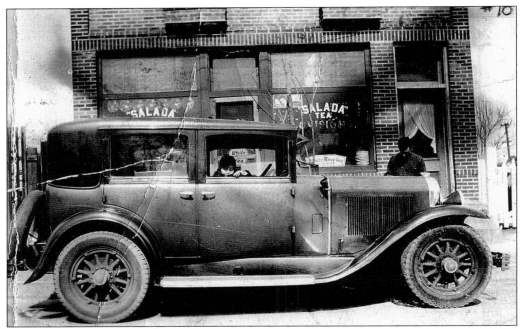

Many families had a grocery store in the front, like this view of 28 Greylock Avenue in the 1930s. Pietro and Cecelia (Policastro) Duca also raised pigs, chickens, goats, and cows on their property. There was a wood-fired smokehouse to smoke pork and a coal and wood stove in the basement where the tomatoes would be canned over a two-week period. Wine was made on a press built right in the cellar. (Courtesy Nicholas Duca Jr.)

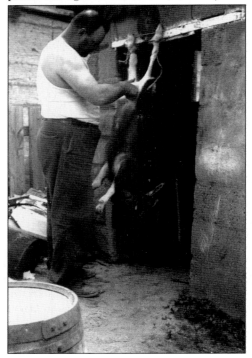

It was common for families to raise their own goats, pigs, chickens, and pigeons in the backyards in Belleville and Nutley. Here a goat is being prepared for the Easter celebration in the backyard on Roosevelt Avenue, around 1932. Families would make soup, traditional Easter bread, and wheat pies, made with grain purchased from the local mill. (Courtesy Mary Ann Carissimo.)

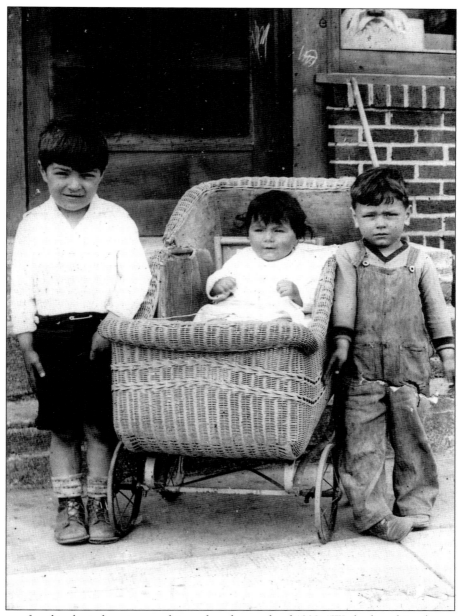

So many families lost almost everything after the crash of 1929. "We had nothing but we had everything," recalled Nicholas Duca Jr. In this 1932 photograph, the "tattered trio," Andrew, Leonard, and Nicholas Duca, pose for a roving photographer in front of their parents' grocery store at 28 Greylock Avenue. Due to the Depression, the store had to be closed soon after this photograph was taken. Notice the safety pin holding up Andrew's pants (there was another one in the back). Overalls are ragged, shoes are ragged and worn, and the baby carriage has no bedding. The baby carriage was recycled by the boys' grandmother (Cecelia Policastro Duca), who was in charge of a nearby dumping site. She brought home items that were still usable or could be repaired. Also note the graffiti on the back door frame—neighborhood art executed by the two older brothers. (Courtesy Nicholas Duca Jr.)

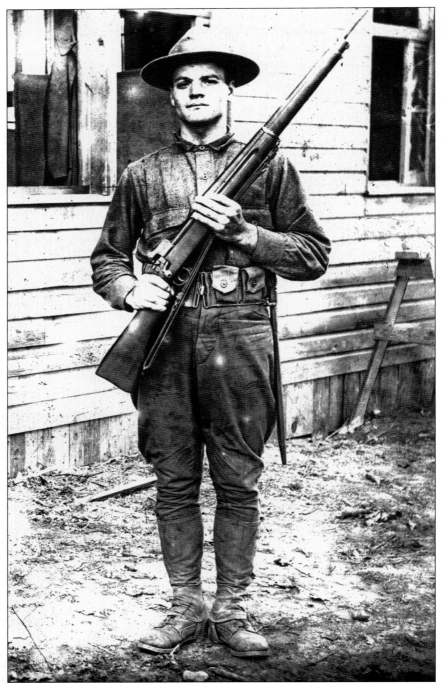

A number of Italian immigrants joined the armed services in World War I. Some obtained citizenship in this way. Domenico Carissimo, born around 1897, came to America around 1912 from Campobasso, Triventi, in Abruzzi. He built a home on Roosevelt Avenue about 1915 and lived there after he married Mary DeNicola Carissimo in 1924. (Courtesy Mary Ann Carissimo.)

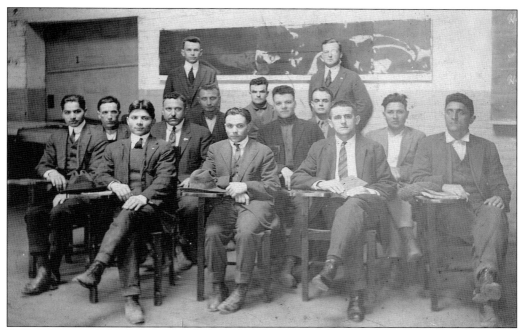

Some immigrants went to formal classes to learn English, as in this c. 1912 photograph. Domenico Carissimo learned English soon after arriving in America, before he went to war. This classroom may have been in Newark. Notice that all the young men are wearing formal clothing. (Courtesy Mary Ann Carissimo.)

Mary DeNicola was born here in 1901 and appears in this photograph about age 17. She married Domenico (facing page) in 1924 at Holy Family Church in Nutley. She had a huge bouquet, and she made her own wedding gown and later made her children's clothes when they were young, as many mothers did. (Courtesy Mary Ann Carissimo.)

About 1920, Christine Anderano Natale is flanked by her son Giuseppe Natale on the left and one of her grandsons on the right. This photograph may have been taken shortly after Christine arrived in America. Giuseppe brought his mother from Italy in 1920, and she helped care for his growing family, eventually five boys and four girls. Giuseppe came in 1910 at age 24 from Foggia, Italy, and he sent for his future wife in 1912. They were married in Newark in Mount Carmel Church. (Courtesy Anne Colon.)

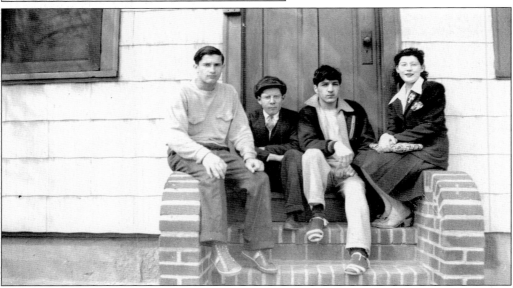

Sitting on the steps in front of 38 Greylock Avenue in 1944 are Patsy Racioppi, Samuel Fusaro, Andrew Duca, and Anne Colon. Giuseppe Natale (above) bought the land at 38 Greylock Avenue and built a two-room home. He added on to the home, as he was able to afford it during the Depression and on his wages as a tinsmith. Neighbors who grew up on Greylock and Roosevelt Avenues have stayed in touch today even though they have moved away from the old neighborhood in the Valley. (Courtesy Anne Colon.)

This couple first moved to the Avondale section of Nutley before settling in the Valley in Belleville. Saverio Fusaro and Louise Fusaro, from Calabria, immigrated to America about 1882 and are shown here probably in the 1920s or 1930s. Saverio was a farmer. (Courtesy Catherine Parigi.)

Vincent Parigi emigrated from Calabria, Italy, in 1910 at the age of 17 years. He was a shoemaker. He also settled in the Valley neighborhood of Belleville. (Courtesy Catherine Parigi.)

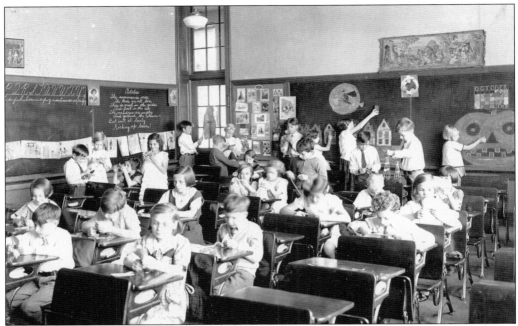

School was a center of socialization and cultural assimilation for children. This is a 1938 photograph of No. 9 Grammar School on Ralph Street, Belleville. Principals and teachers are remembered for their dedication and caring, for taking children on trips, and for purchasing clothing or sports equipment for them when families could not afford it. (Courtesy Anne [Giorgianna] Hult.)

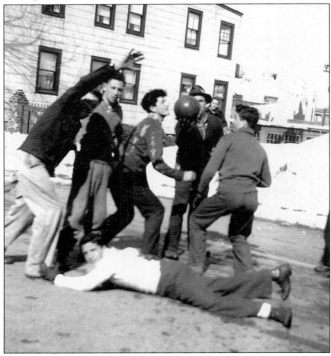

Neighborhood boys play outside in front of 30 Greylock Avenue in the winter of 1948. Laundry can be seen drying on the clothesline in the background. Jerry Raccioppi is on the ground. Shown are, from left to right, Paul Vesey, Willie Gerard, Tony Long, Pat Racioppi, and Lenny Duca. (Courtesy Nicholas Duca Jr.)

Another view of Greylock Avenue is shown here, with the six Giorgianni sisters about 1948. The two brothers do not appear in this photograph. Their parents, Stephano Giorgianni and Caterina (DiBella) Giorgianni, came from Messina, Italy, in 1903 and settled in Belleville about 1904 and lived at 90 Greylock Avenue. A cousin also lived in the home when he came over from Italy. There was always company at home and people coming over. (Courtesy Anne [Giorgianna] Hult.)

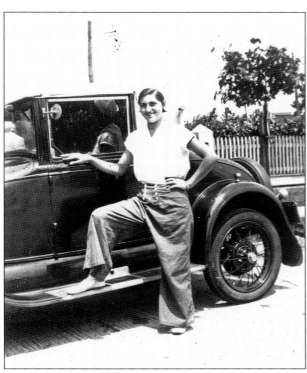

One of the Giorgianni sisters, Josephine, leans against a 1929 Ford convertible on Greylock Avenue in 1933. (Courtesy Anne [Giorgianna] Hult.)

This photograph was taken in Newark, around 1939, probably by the roving photographer. Schrafft's Candy Store can be seen in the background. Two sisters, Jennie (left) and Sally (Santina) Giardina, are shown. They later married two brothers, James and Angelo Corino. The extended families lived at St. Mary's Place, "Corino Villa," in three two-family homes built by the brothers' parents, Carmen Corino and Maria Capalbo Corino. There were also garages and adjacent properties that housed the trucks, heavy excavation equipment, and related business equipment and supplies for the family business. Carmen and Maria emigrated from Calabria in 1908 and 1910 and had eight children. (Courtesy James Corino.)

From right to left in this photograph are Jim Corino, his father James Corino, and mother Jennie (Giardina) Corino. James was the fourth of the five sons of Carmen and Maria Corino. Jim was the second grandson and the first of three boys that James and Jennie would have. This photograph was most likely taken at a family wedding around 1949 or 1950. (Courtesy James Corino.)

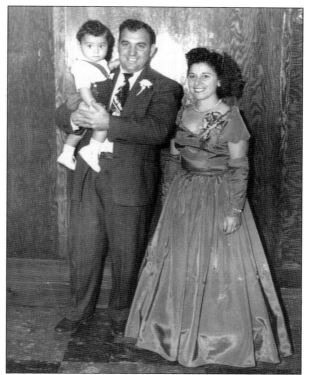

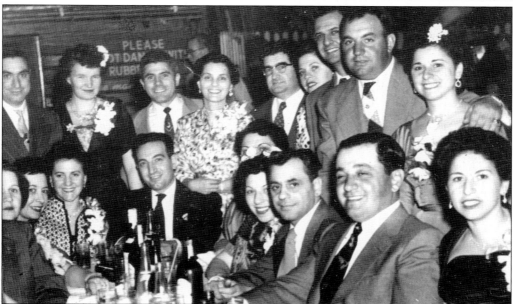

Extended family was always important. This c. 1953 photograph is of the "Cousin's Club," a gathering of the Corino and (Macca) Giardina family cousins. Macca is the maiden name of Jennie and Sally (Giardina) Corino's mother. They met once a month at either someone's home or, as in this picture, at a local dance hall, for more than 30 years. The sign in the background reads, "Please do not dance with rubber shoes." (Courtesy James Corino.)

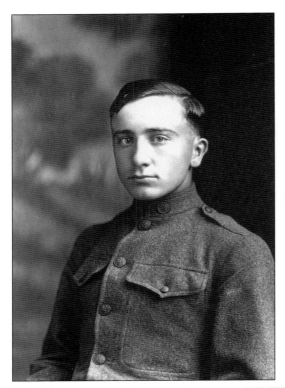

Edward M. Rizzolo is shown here in 1920, after he was discharged from the army. He served in the First Division attached to the French army, in the Ambulance Corps. He received the Croix de Guerre, the French medal for bravery. He left premed school to enlist in the army in 1916. He graduated from Baylor University College of Medicine in 1925 and interned at St. Michaels Hospital, Newark, in 1926. He established a general medical practice in 1927 and practiced for 32 years at 523 Union Avenue in Belleville. His parents were from Calabritto. Vito A. Rizzolo and Maria Fillipone Rizzolo had 10 children, all born in Newark. They lived on Mount Prospect Avenue. (Courtesy Edward Rizzolo.)

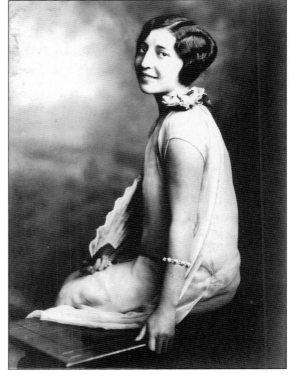

Born in Calabritto, Josephine (DiGeronimo) Rizzolo came to America at the age of eight, in 1907. She had four brothers and four sisters. She worked for a dressmaker in Manhattan who would send her to fashion shows in New York. She sketched what she saw, and they would design dresses based on that information. She married Dr. Edward M. Rizzolo, above. This photograph is from around 1920. (Courtesy Edward Rizzolo.)

Three

NUTLEY

The three Italian American neighborhoods in Nutley in the early 1900s were Avondale, Big Tree, and Milton Avenue's Nanny Goat Hill (also known as "the Hill" to residents).

In the 1920s and 1930s, winemaking was a big part of life on the hillside between Bloomfield Avenue and the Morris Canal. Some immigrants had brought their own vines from Italy. The Creccas had watered their vines in the pots during the two-to-three-week crossing. The Creccas used to harvest more than five tons of grapes, and, when it was legal to do so early in the century, they made all the wine for Crecca's Tavern. The Scarpellis also had one of the largest vineyards until the 1950s. Other families with vineyards were the Grossos, the Nigros, the Bolognis, the Serritellas, and the Petrellas.

Ritacco's Tavern in Avondale was a center of neighborhood life, as were Cavallo's and Mecha's Candy Store. In Big Tree, Zinicola's Bakery offered home delivery. Many things were delivered in the early 1900s, such as milk, bread, eggs, meat, and even snails, which were then prepared at home with garlic and butter. In summer, the watermelon man Mr. Verrico came by, as did "Lay Dress," so named because he called out "Lady Dress, Lady Dress" to sell his dry goods. A sharpening man would sharpen scissors and knives and sharp instruments. Many houses were heated with wood-burning stoves, with a grate in the floor to allow heat to rise to the second floor. Another neighbor had a makeshift saw machine on the back of an old truck; he would cut wood for people to store up for their wood stoves and heaters.

Like other towns, Nutley had organizations established by immigrants from a particular town in Italy. The San Gennaro Society was one example—a social club established by *paesani* from Joppolo, Caroniti, Catanzaro, Italy. The immigrants from Joppolo began to arrive in the early 1900s, and they settled on Bloomfield Avenue south of Chestnut Street. They also settled on the side streets, such as Newark Avenue, Entwistle Avenue, and Franklin Avenue. Some of the names were Corsaro, Cullari, Corigiliano, Falduti, Mazzeo, Mazza, Furci, Messina, Papparato, Polito, Vecchio, and Zappia. San Gennaro was the patron saint of Joppolo, and he was greatly revered by the families transplanted to Nutley. The San Gennaro Society met once a month at a member's home until the 1990s.

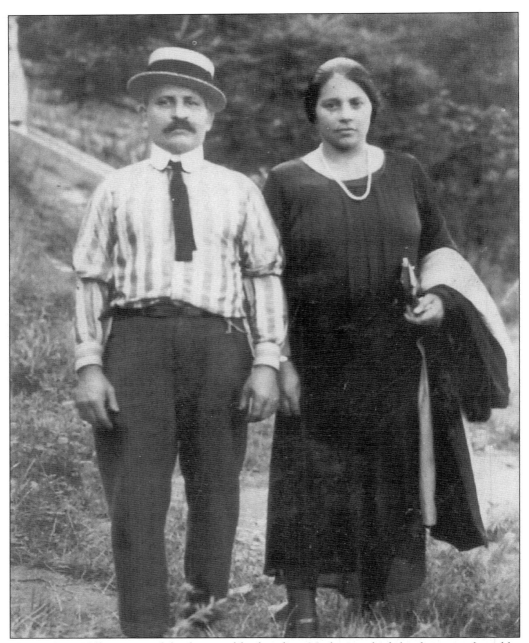

Nanny Goat Hill was one of the first neighborhoods in Nutley in which land was purchased by Italian immigrants. Here are Vito and Serafina Pignataro, in about 1898, before leaving from the town of Bella, in the province of Basilicata. They settled in New York City before coming to Nutley to stay with Vito's parents, Antonio and Maria, who had purchased land in Nutley in 1881. Vito worked in New York City as a street sweeper and came home to Nutley on the weekends. (Courtesy Peter Scarpelli.)

In the early 1900s, Milton Avenue was a dirt road with many open fields. Winemaking was popular, and many families had large vineyards. Some families had vines brought over on the ship from Italy. Here Joseph Pignataro, brother of Vito, embraces an unidentified woman beside a wire fence near a vineyard on Milton Avenue. (Courtesy Peter Scarpelli.)

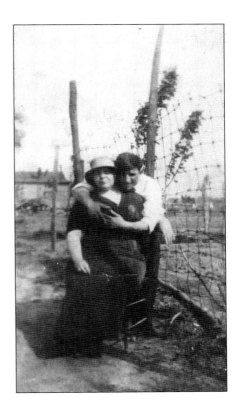

Maria Pignataro Gerbasio, one of the 16 daughters of Vito and Serafina, poses with four of her eight children in 1907. (Courtesy Peter Scarpelli.)

Pietro Ruffo and his children stand amid their grapevines and beside the fence at 72 Milton Avenue in Nutley, around 1937. (Courtesy Steven Mairella.)

Frank Ruffo, one of the seven children of Pietro Ruffo of Milton Avenue, served in World War II. He was 18 years old when he was drafted and taken out of high school six months before graduation in 1944. He served two years in Europe, then married his childhood sweetheart, Esther Tarantino, also from Milton Avenue. (Courtesy Steven Mairella.)

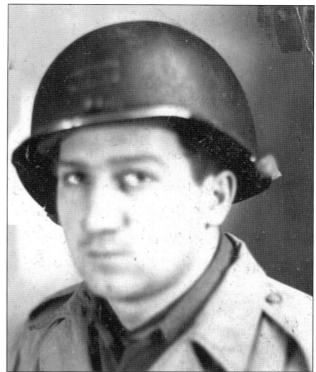

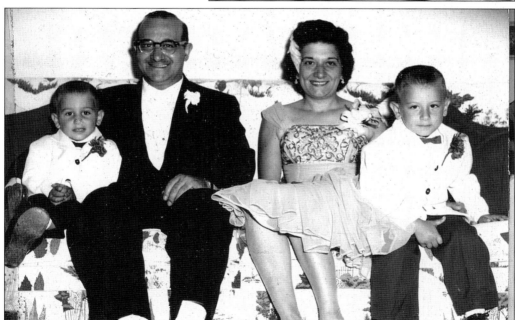

Pietro Ruffo's daughter appears in this photograph with her husband and children around 1960. They are, from left to right, Daniel Mairella, Carmine Mairella, Marie (Ruffo) Mairella, and Steven Mairella. Marie and Carmine married in 1952 in Nutley at the Italian Pentecostal church on Milton Avenue. (Courtesy Steven Mairella.)

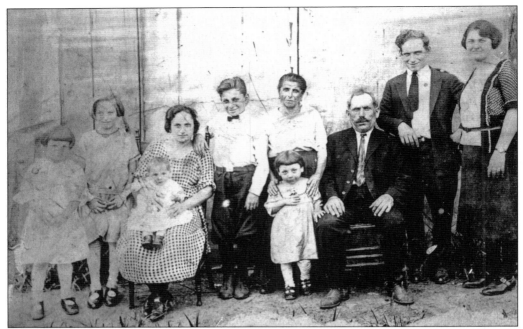

Around 1922, the Cocchiola family ancestors can be seen. In the photograph from left to right are Julia (Cocchiola) Verrico, Josephine (Cocchiola) Malizia, Antoinette (Restaino) Cocchiola with Frank Cocchiola Sr. seated on her lap, Gabriel (Al) Cocchiola, Josephine Restaino with Marie (Cocchiola) Cascino standing in front of her, Pasquale Restaino, and his son Angelo and daughter-in-law Pauline Restaino. (Courtesy Joanne Cocchiola.)

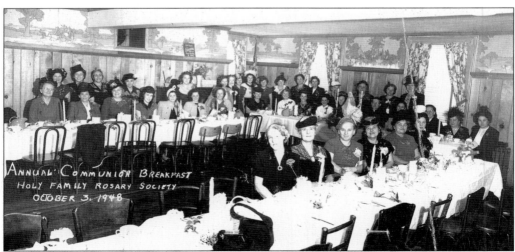

In 1948, this was the annual communion breakfast of the Holy Family Rosary Society. Anna (Restaino) Cocchiola is seated third from the left at the table in lower right corner. Anna married Generoso Cocchiola in 1911, and they had five children. (Courtesy Joanne Cocchiola.)

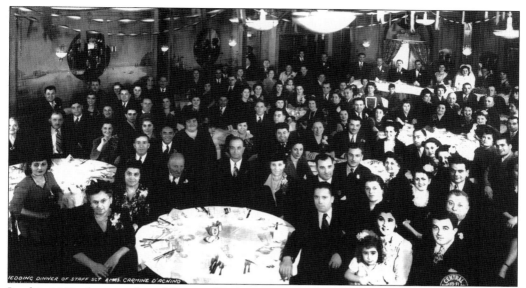

In this 1943 photograph at Vittorio Castle, many members of the Orechio, Cocchiola, and Restaino families, among others, attend the wedding dinner of Staff Sgt. Carmine D'Achino and his bride Mary Cocchiola. (Courtesy Carmen A. Orechio.)

This is a backyard on Hunt Place in Big Tree. On the left is Generoso (Joseph) Cocchiola with Frank Luzzi. In 1915, Generoso built a house at 11 Morris Place. In 1921, he built a house on Hunt Place behind his garage on Washington Avenue, where he repaired cars and bicycles. He also made his own accordions and taught every grandchild to read music. (Courtesy Carmen A. Orechio.)

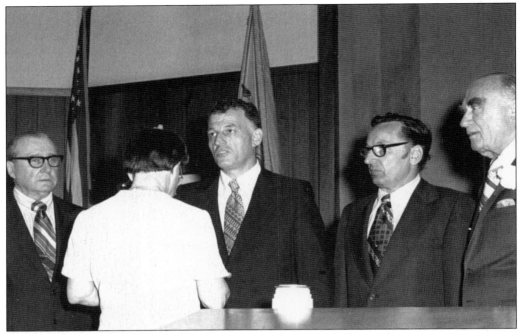

Carmen Orechio, Nutley's first Italian American mayor, appears here at the swearing in ceremony in 1972. He served three terms as mayor and also served as president of the New Jersey State Senate from 1982 to 1985. (Courtesy Carmen A. Orechio.)

Celia and Peter Scarpelli Sr., first-generation Americans, stand here in 1938 with their son Peter Jr., who later became the 14th mayor of Nutley. Celia was one of the 16 daughters of Vito and Serafina Pignataro of Milton Avenue. (Courtesy Peter Scarpelli.)

Eileen (Crecca) Poiani and cousin Dorothy (Petillo) Moran are pictured here with their grandmother Donata Crecca around 1928. Eileen's grandfather owned Crecca's Tavern on East Passaic Avenue, across the street from the Morris Canal. In the late 1920s, Eileen used to row her grandfather's canoe to take commuters across the canal for 5¢. (Courtesy Eileen L. Poiani.)

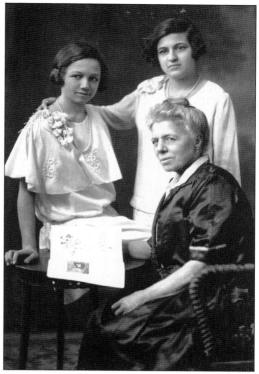

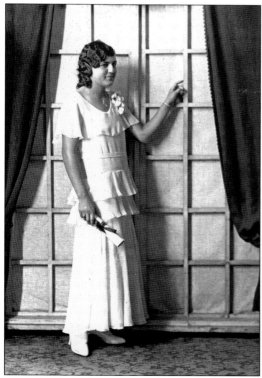

Eileen (Crecca) Poiani has always been very fashionable. Her wedding dress was from Bamberger's in Newark. As a legal secretary, she worked for Judge William Camarata and Paul Maher in Montclair and walked to the bus in knee-deep snow. She also worked for Schotland and Schotland, Esqs.; and for Blue Shield Blue Cross in Newark; and for Donohue and Donohue in Nutley. During the Depression, pay was about $7 a week, just enough for the bus ride. Eileen graduated from Nutley High School in 1931. (Courtesy Eileen L. Poiani.)

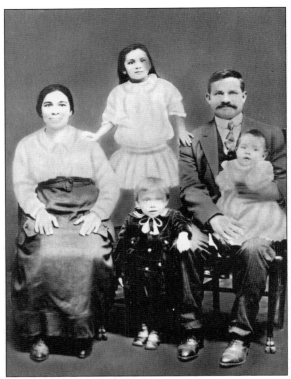

Caterina Furci Corsaro and Sabatino Corsaro from Cononiti, Catanzara, southern Italy, were born in 1883. Sabatino came in 1911 to send money back to his family. The town was populated by poor farmers; they had only what they could grow. People lived on the barter system. Sabatino came to work on the railroad. Caterina arrived two years later, about age 29, and bore four children here. She had had two boys in Italy who died in an encephalitis epidemic. Domenica "Mecha" Corsaro was one of her children, and she later married Domenico DiCioccio (below). (Courtesy Kathleen Bissell.)

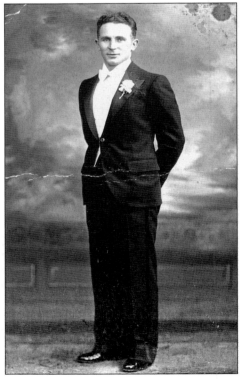

Domenico DiCioccio, born 1909 in Pratola Peligna (Abruzzi), immigrated about 1929. DiCioccio took English courses and was always very supportive of education and of culture and learning. Domenico's father, Emideo, came in the early 1900s, but Emideo's wife and two daughters stayed in Italy. Emideo also took English courses and was always very supportive of education and of culture and learning. Emideo went back to Italy in 1937 for the last time. He found that Benito Mussolini had confiscated his family land, grape vines, and olive trees. (Courtesy Kathleen Bissell.)

Domenica Corsaro at age 15, seen here in 1929, stands in front of Lincoln School, which she attended. At age 14, she left school to work in the mill to help support the family. She married Domenico DiCioccio and became the proprietor of Mecha's Candy Store. Her parents, Caterina and Sabatino (facing page), emigrated from southern Italy. (Courtesy Kathleen Bissell.)

Domenico DiCioccio poses with daughters Kathleen and Fran in front of their home at 243 Bloomfield Avenue. The cement blocks on the foundation were hand made by the girls' maternal grandfather, Sabatino Corsaro, when he built the house in 1926. Sabatino also sold the blocks for 5¢ each to make extra money for the family. The family made grape juice, wine, and grape jelly with the concord grapes that grew on vines planted in back. (Courtesy Kathleen Bissell.)

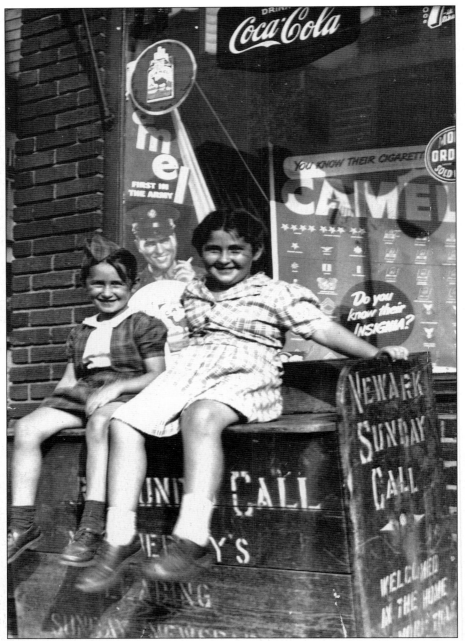

Mecha's Candy Store was a center of the Italian community in Nutley, the place people came to make and receive telephone calls, as many did not have telephones. Neighborhood information would be exchanged there, including scores of the baseball games during the World Series and information about which servicemen and servicewomen were home on furlough during the war. In 1942, Kathleen and Frances DiCioccio sit in front of the store. "Mecha" was Domenica (Corsaro) DiCioccio, their mother, who worked in the store all day. Their father, Domenico, worked there when he came home from work at the mill. When the store was sold in 1960, and the name changed to Davis', everyone still called it Mecha's. (Courtesy Frances Capalbo.)

This photograph was taken in front of 243 Bloomfield Avenue, looking down Taft Street. Anna Corsaro Zappia, sister of Domenica (Corsaro) DiCioccio, is picking peonies in front of the family home in 1950. (Courtesy Kathleen Bissell.)

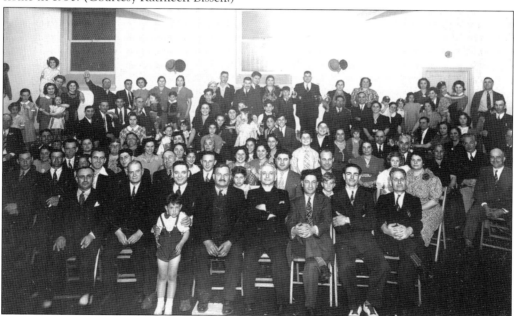

The first annual dance by the San Gennaro Society was in 1940, held in the basement of Holy Family Church on Brookline Avenue. The society was a social club established by immigrants from Joppolo, village of Caroniti. San Gennaro was their patron saint and was much revered by the families. The women's group of the society continued meeting once a month at a member's home until the 1990s. (Courtesy Frances Capalbo.)

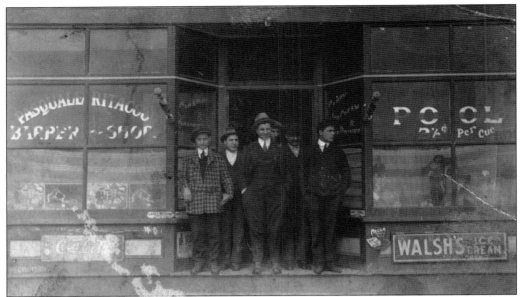

Ritacco's Tavern was a gathering point in Avondale. Originally there was a candy store, a grocery store, and a pool hall. Pasquale Ritacco, born in 1891, came to America in 1907 and married Carmela Gulla. Pasquale's father, born in Acri, immigrated in 1883 and was among the pioneer Italian settlers of Nutley. Here on the right, Pasquale stands in front of the barbershop around the 1930s. The tavern was to the left, and the grocery store to the right. (Courtesy Andrew P. Mastandrea.)

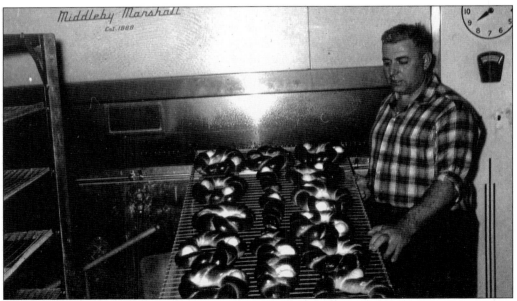

Sal Sposato, husband of Esther Zinicola, bakes Easter bread in 1950 at Zinicola's Bakery. The Easter bread is an old family recipe brought from the old country and is still made today every Easter. It is a sweet bread, with whole hard-boiled eggs baked in the bread. It has a sugar icing or can be made plain and is eaten plain or with butter, often with coffee. (Courtesy Gerard Tolve.)

Seen in this photograph, taken about 1930, are, from left to right, (first row) Domenica Laurite, Rachel (Laurite) Pfifer, and Jack Laurite; (second row) Joseph Laurite, Agostino Laurite, and Rita (Laurite) Sposato. The Laurites were originally from Naples, and the family settled on King Street in Nutley, in the Big Tree neighborhood. (Courtesy Thomas Sposato.)

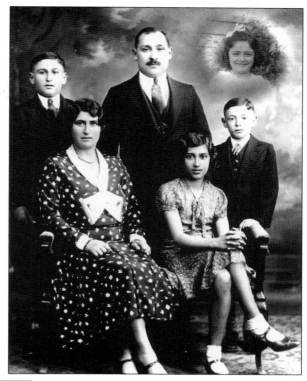

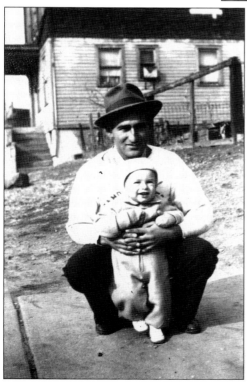

Joseph Laurite and Joseph Laurite Jr. stand in front of 100 King Street in Big Tree. (Courtesy Thomas Sposato.)

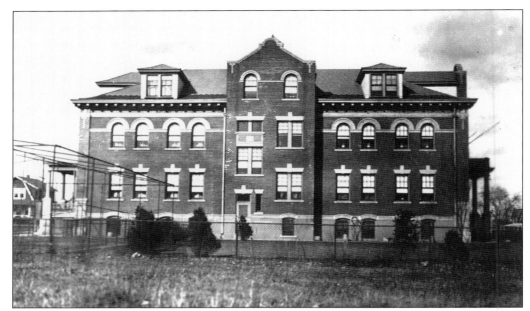

The New Jersey Grand Lodge of the Order Sons of Italy in America was chartered in 1911. It was the second lodge in the Order Sons of Italy in America. In 1923, the Grand Lodge of the Order Sons of Italy in America opened an orphanage in Nutley that functioned until 1970. This photograph of the building is from the 1930s. (Courtesy Immigration History Research Center, University of Minnesota.)

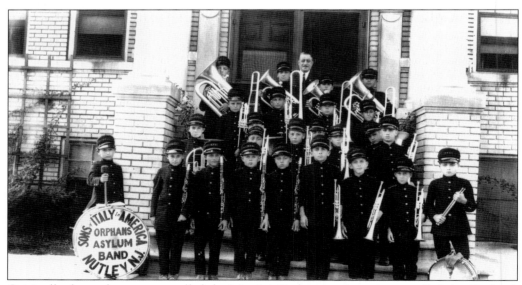

Originally the orphanage was called the Mazzini Orphanage. Later it was called the Orphan's Home of the New Jersey Grand Lodge. The writing on the large drum in the lower left corner reads, "Sons of Italy in America, Orphans Asylum Band, Nutley, NJ." This photograph is from the 1930s. (Courtesy Immigration History Research Center, University of Minnesota.)

Four

THE DIGNITY OF WORK

Work was an economic reality and a challenge. Laborers worked on the railroads, in the quarries of Nutley, and on the construction of the Sacred Heart Cathedral in Newark. Many immigrants opened a small store and lived above or in the back. On the streets others sold produce harvested from gardens or farms in Belleville and Nutley. Everything was sold on the streets from carts—clothing, tomatoes, olive oil, sweet potatoes (the "Sweet Potato Man"), chestnuts, and even snails. Milk and other products were delivered; ice-cream trucks also made the rounds.

Immigrants opened barbershops, butcher shops, macaroni factories, and bakeries. They started construction companies and paved the runways of Newark Airport and the local streets. Families opened candy stores and taverns, which often served as a center of Italian American social life and communication. Children helped their parents or had jobs of their own. A seven-year-old boy lit the Newark gas lamps every evening and put them out every morning, for a penny a lamp. Others worked for the Troy laundry, delivering towels and linens to the old Morris Avenue Bathhouse in Newark. Another helped his father by hand cranking the merry-go-round rigged on an old flatbed truck. They traveled around to provide rides to neighborhood children for a penny.

Italian American women worked long hours in the family store or business, in addition to caring for home and family. Many women from Belleville and Nutley worked at Plenge's farm (which was sold in 1958 and became the Rutan Estates Housing Subdivision). They arrived at 7:30 a.m., carrying their lunches on their heads. They passed the time singing as they worked in the fields. One woman sang, the others joined in the chorus. The singing was remembered as "ethereal, like church bells ringing." Other women worked as domestics. Sometimes women did piecework in their homes, such as making beaded dresses. Delivered by local factories, this was known as "home work." Women and men worked in the garment industry, as tailors or as weavers, in factories, at Oakes Mill, and even in Thomas Edison's factories in West Orange. A Belleville woman was asked to bead a dress for Mrs. Thomas Edison.

Subsequent generations of Italian Americans began to enter politics, the arts, and other professions in increasing numbers.

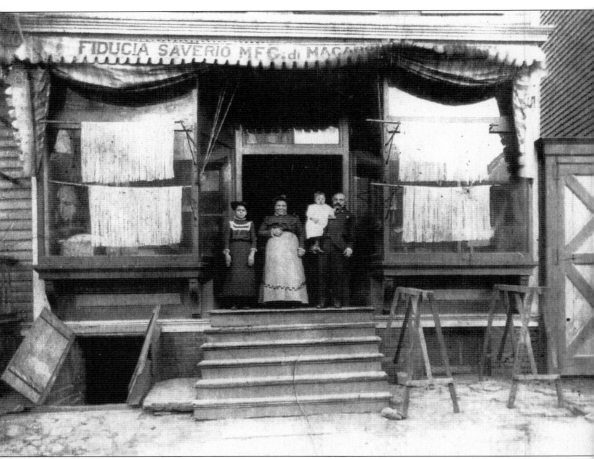

This is a Newark macaroni factory at 288 Morris Avenue about 1920. The pasta drying on poles can be seen. The macaroni manufacturing was on the first floor, and the family lived in the second floor. The building had been purchased in 1904. Each floor had a fireplace, and there were gaslight pipes and valves in the wall where the electric outlets were installed when electricity came. There was no central heating, and the only toilet was in the cellar. There was a single potbellied stove in the kitchen, the only source of heat. The children would study in the public library, where there was heat and good lighting. There was no hot water heater, but the Morris Baths were across the street. Gene Fiducia, as a child, worked for the Troy City Laundry as a truck driver, helping deliver towels and picking up towels and bathing suits. (Courtesy Gene Fiducia.)

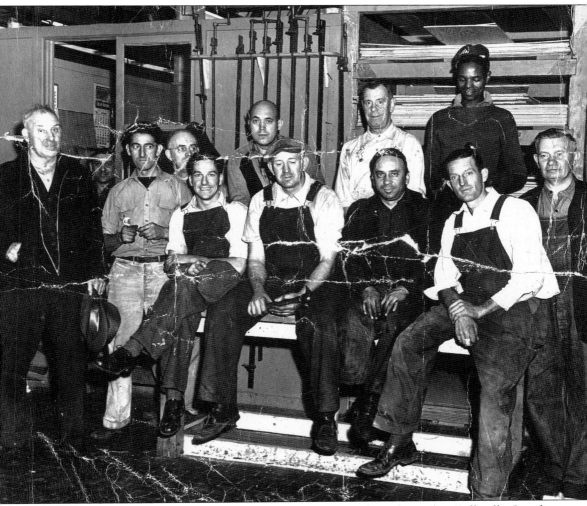

The Walter Kidde Company made firefighting equipment and was located in Belleville. Local Valley residents remember that during the war, the company operated 24 hours a day. There was an airplane engine inside to test parts for the planes, and the noise could be very loud at times. The company had purchased a piece of ground in the back of Roosevelt Avenue called Capital Field by nearby residents in the Valley neighborhood. This photograph of Carmine (Charles) D'Amato and others is from the 1940s. (Courtesy Deanna Hohmann.)

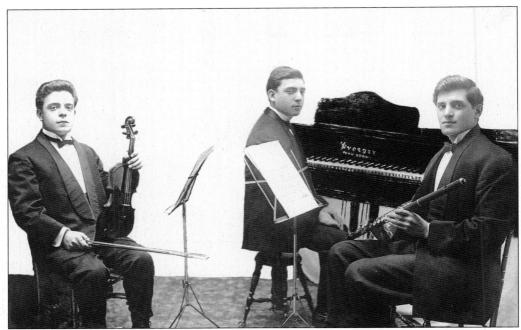

In this 1930s photograph are Ralph, Ulisse, and Herman Gildo Senerchia, who were all musicians, as was their father, who had been a musician in Italy. They played in concerts in the tristate area, and they also had family concerts at home. (Courtesy Elissa Senerchia.)

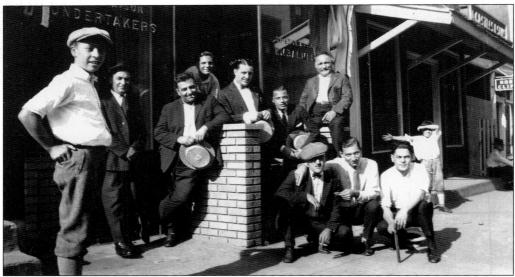

The Spatola family worked out of a storefront at 135 Eighth Avenue in Newark for funerals until 1934, when they purchased a mansion and renovated it to become the Spatola Funeral Home. In this c. 1926 photograph, Gerardo Spatola Sr., Arturo Cafaro, and others gather informally in front of the storefront. The word "undertakers" can be seen on the sign in the upper left corner. (Courtesy Spatola family.)

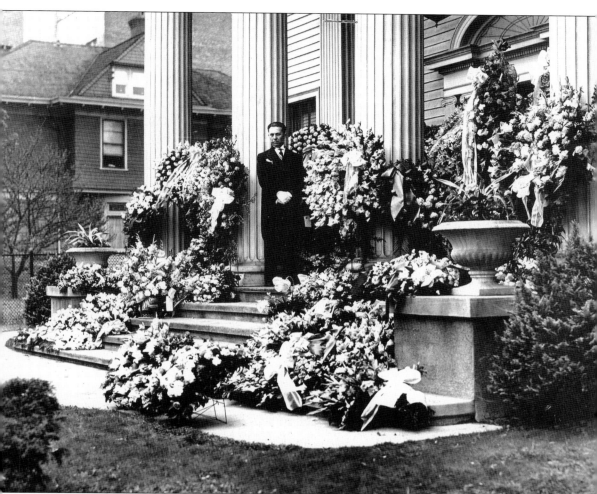

This is the Spatola Funeral Home in the 1940s, after the mansion was renovated, at the funeral of Gerardo Spatola Sr. There were so many flowers that they had to be placed outside the funeral home. The mansion on Mount Prospect Avenue was purchased in the 1930s, and extensive renovations were done to make it a state-of-the-art funeral facility, as well as beautiful building. The Spatola family started and ran the first Italian American funeral home in the state of New Jersey. (Courtesy Spatola family.)

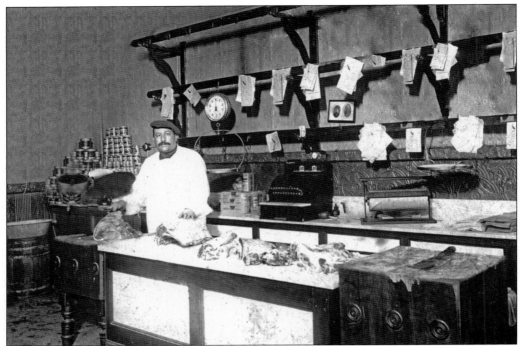

Francesco Amico is the proprietor of this butcher shop in Down Neck Newark, around 1925. (Courtesy Rev. Thomas D. Nicastro.)

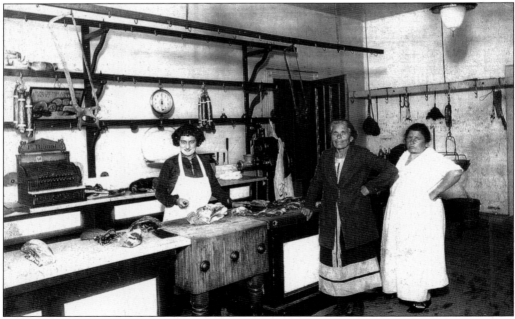

Madeline Biondi, age about 18, stands at the counter of her family's butcher shop, located on Sixth Avenue, Newark, about 1923. Her mother, Maria (Manna) Biondi, had died in 1916, when Madeline was only 11. Her father, Frank Biondi (see page 13), taught her to be a butcher. She was his oldest daughter. There are two customers in the shop. (Courtesy Deanna Hohmann.)

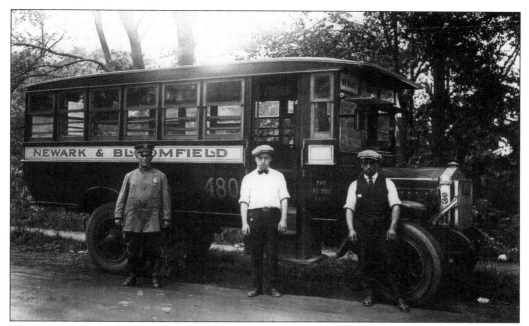

The Newark-Bloomfield bus, pictured here in the early 1900s, ran from Bay Avenue, Bloomfield to Lincoln Avenue, Newark. One can see an unidentified police officer; the bus owner and driver, Anthony Bologni; and an unidentified footman. The bus is parked on East Passaic Avenue, then a dirt road in Nutley. (Courtesy Peter Scarpelli.)

Around 1930, these are the trolley car workers of Nutley. Agostino Laurite is in the front row, lower right corner. Frank Cocchiola Sr. is in upper left corner. (Courtesy Thomas Sposato.)

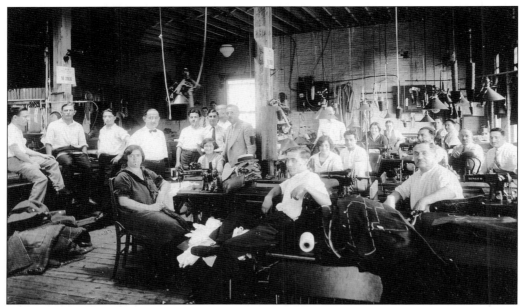

This is the Milton Tailoring Company on High Street in Newark, around 1925. One can see the sewing machines and cut pieces of garments piled in the lower right and lower left of the photograph. There is also a pile of garment pieces in the center, with a hat on top of the pile. Antonio Russomanno, who immigrated to America in 1920, is in the center, standing, with the tie and dark hair. (Courtesy Susan Berman.)

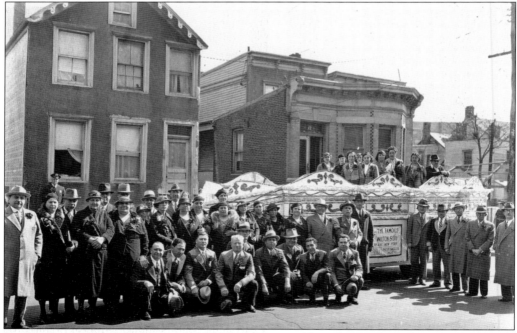

Employees of Wilton Suits Factory, 14 Milton Street in Newark, march in the May Day parade on Fifth Avenue in New York City in 1935. Stefano Alfano is third from the right. (Courtesy Emanuele Alfano.)

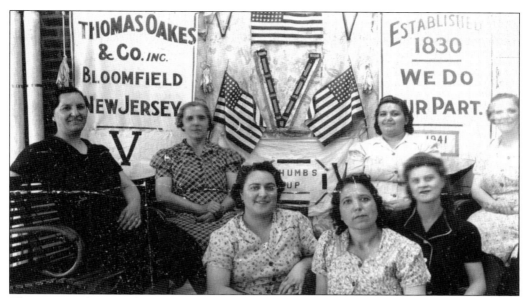

These are workers at Thomas Oakes and Company, in Bloomfield, around 1938. Many of the immigrants from Caroniti worked at the mill. In this picture are Domenica DiCioccio (known as "Mecha"), Anna Francisco, and Anna Ferrucia. (Courtesy Frances Capalbo.)

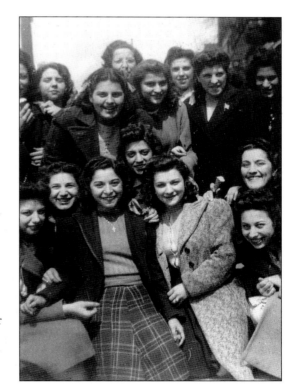

Workers from the Linbro Dress Company in Belleville pose about 1941. Jennie Giardina is in the middle of the photograph with the plaid skirt, and to her right is her high school best friend, Millie Coppola. Giardina worked at Linbro Dress Company after high school. (Courtesy James Corino.)

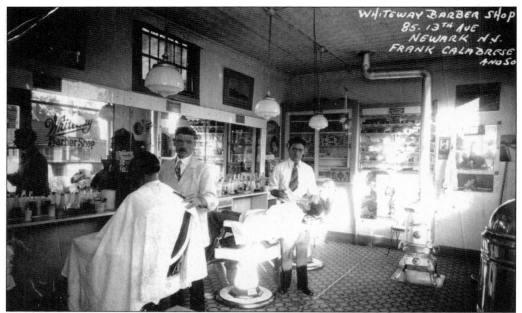

The Whiteway Barber Shop, at 85 Thirteenth Avenue in Newark, was run by Francesco Calabrese and his son Michael. The family also lived there. Francesco was an immigrant to Newark from Bari, Apulia, in the late 1800s. His wife was Leonilda Lanza. Francesco's son Michael (see page 22) later owned the Parkview barbershop close to 520 Broad Street; the Columbus monument was across the street. A potbellied stove can be seen on the floor to the right in this 1927 photograph. (Courtesy Lilian Vizzuso.)

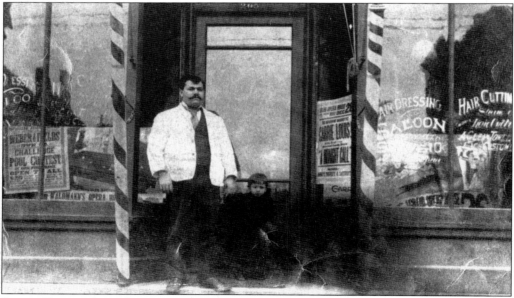

Donato Esposito (son of Francesco Esposito) was a barber who immigrated to Newark in 1880 and married Angela Maria Gerardo, age 19, in 1887. She was born in San Fele and had immigrated to Newark with her parents, the Vincenzo Gerardos, about 1877. (Courtesy Judith and Frank Molinaro and Robert Cardone.)

Joseph Bono, around 1950, worked in the Frank Barbershop on Franklin Avenue in Belleville. In 1955, he started his own barbershop in Newark with his brother Vincent, at 559 Bloomfield Avenue, an area known as Tri-city. Joseph learned the trade of barbering at the age of nine in Palermo, Italy. Now his barbershop is located on Centre Street in Nutley. (Courtesy Joseph Bono.)

This picture portrays workers at Industrial Wire and Metal Works, located at 216 Oraton Street in Newark in the early 1920s. Anthony D'Amato is the fourth from left. The men went to work in suits. (Courtesy Ellen and Raymond D'Amato.)

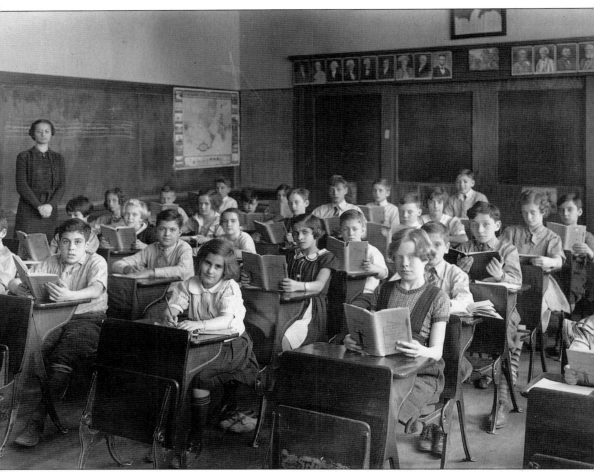

Phyllis Calicchio Cupparo was a teacher at School No. 7, located at Joralemon Street and Passaic Avenue in Belleville, for 40 years. For 18 years, she lived in the same neighborhood as the school, which was the same school she and her siblings had attended. She taught the children and grandchildren of her early students, as well as some of her own family members. When she married in 1943, she invited her students to the wedding. This is her classroom in 1935. (Courtesy Phyllis Marie Cupparo.)

Hugo F. Poiani stands near his plane at Wheeler Point Field in Hawaii, about 1931. He was crew chief on the plane for the Army Air Corps. Poiani was born at 44 Garside Street in Newark, in 1909. The midwife's name is listed on his birth certificate. Poiani's parents were from Ancona and Turino, Italy. His father was a tool and dye maker who designed precision instrument panels for aircraft. (Courtesy Eileen L. Poiani.)

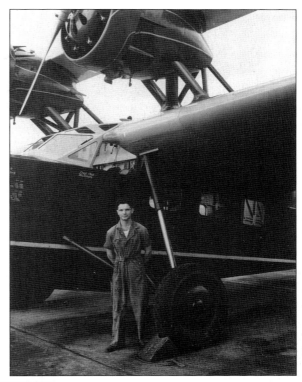

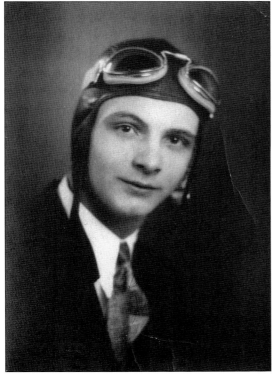

Poiani was in the aviation industry all his life with Bendix Aviation (now Honeywell) in Teterboro, New Jersey. He was an aviation troubleshooter, and he traveled extensively. Poiani grew up in Newark and moved to Nutley when he married Eileen Crecca in 1941. This photograph was taken about 1930. (Courtesy Eileen L. Poiani.)

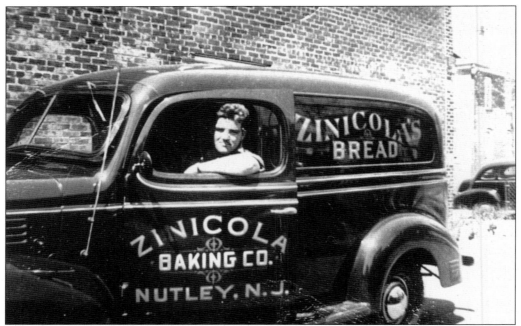

John Zinicola established Zinicola's Bakery in Nutley at 127 King Street, where the bakery operates today. Originally a grocery store was attached to the bakery. John Zinicola Jr. shows off a new delivery truck in 1939. The Zinicolas immigrated to America in late 1800s from Mindorno, Italy, where they had been bakers as well. Mariano Zinicola and his sons had a bakery in Staten Island around 1910. (Courtesy Gerard Tolve.)

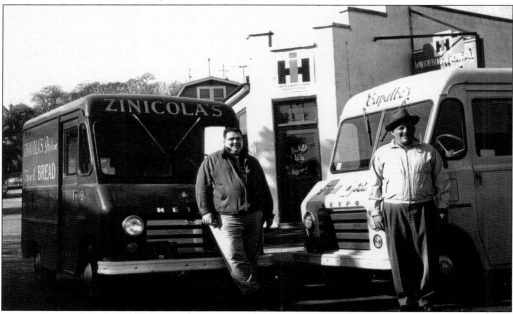

Around 1949, John and Frank Capalbo stand in front of A and F Truck Company, picking up their new truck. A and F, at 55 Washington Avenue in Nutley, was owned by Al and Frank Cocchiola. (Courtesy Gerard Tolve.)

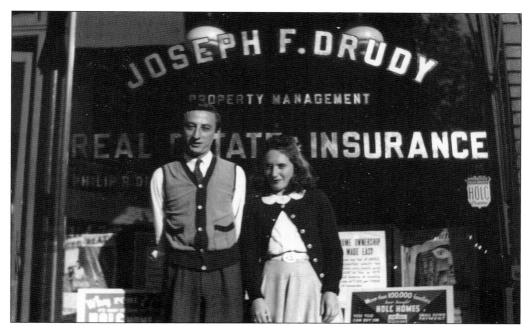

Alderina Stefanelli poses here with Joseph F. Drudy, her boss. She worked at his insurance company after graduating from Central High School in the secretarial track. She earned $6 per week. Her parents, Enrico and Elizabeth (see page 4), purchased their last home (having lost their previous home during the Depression) through Drudy's real estate agency. This photograph is from 1940. (Courtesy John Rendfrey.)

Josephine Biondi D'Amato worked at Pacific Mutual in this c. 1950 photograph. During the Depression, while single, she worked at Prudential and was the only one in her family with a job. Frank Biondi (see page 13) was her father. (Courtesy Deanna Hohmann.)

Carmine Mairella, of Newark and Nutley, was an artist and a sign painter. He is shown here working in Newark, around 1946. He was a member of the team that painted the famous "Hoffman Soda Bottle" water tower in Newark. The photograph at left may be in Ironbound. The photograph below is at Meier's Sign Shop in Newark. From left to right are Charlie Meiers, an unidentified coworker, and Carmine Mairella. (Courtesy Steven Mairella.)

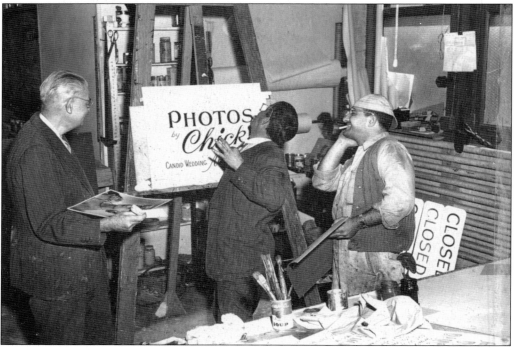

Making ravioli was a common activity, yet photographs are rare. Here Bessie Caruso and Catherine Coppola make ravioli in 1948 for a family celebration. Notice the extra-long rolling pin. The women used to roll the dough and flap it. Five-year-old Marianne Coppola would help to seal the edges with a fork, then place them on a tablecloth on the bed and count them. (Courtesy Marianne Coppola.)

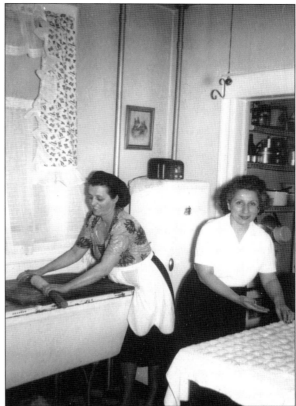

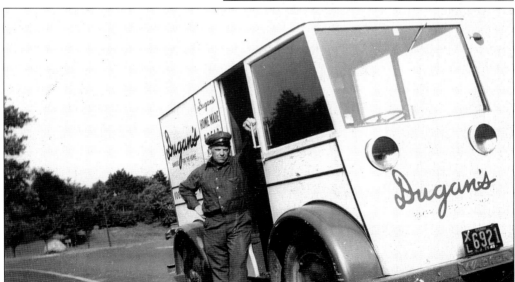

Dugan's trucks delivered bread, eggs, and cake to families' homes. Alfred Coppola Sr. worked as a delivery driver, shown here in 1947. Everything was delivered in those days, or could be bought on the street, including milk, olive oil, canned vegetables, and fruit. The Dugan's trucks were electric and had to be charged and serviced at night. (Courtesy Marianne Coppola.)

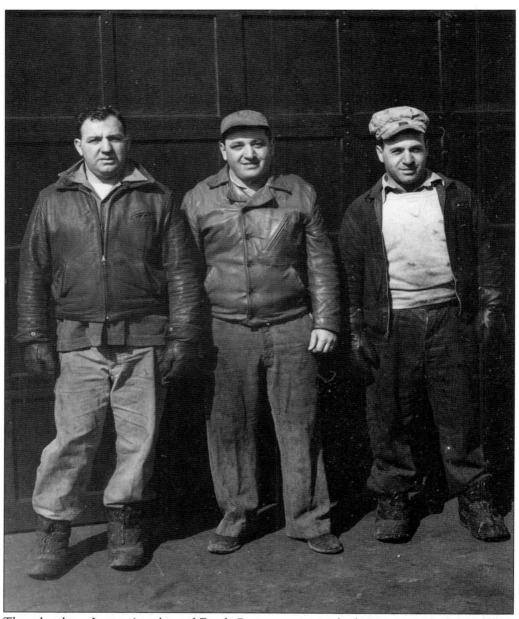

Three brothers, James, Angelo, and Frank Corino, pose outside the garage on St. Mary's Place around 1955. This is where the family kept the company work trucks, and they lived in adjacent buildings. The company name was C. Corino and Sons; they were trucking and excavation contractors. (Courtesy James Corino.)

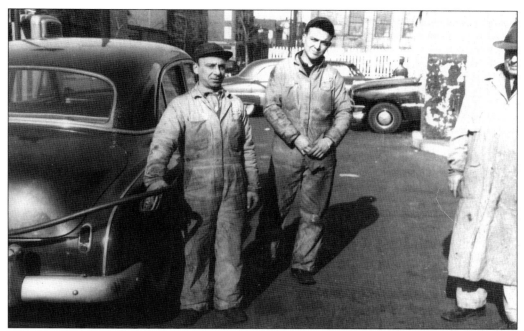

The First Ward Service Station, seen here around 1950, was located at the corner of Seventh and Sumner Avenues. Archie De Filippis owned and operated this business for 35 years. The price of gas was 23.9¢. The service station was patronized by Joe DiMaggio, among others, and was a gathering place for the neighborhood men who told stories, often in Italian. (Courtesy Roy R. De Filippis.)

Margaret Blasi worked part time at Prudential Insurance, in the Washington Building on Washington Street in Newark, while she was still attending West Side High School. After graduation, she worked full time and was given her own desk and no longer had to work in the files. This photograph is from 1954. Blasi is the daughter of Michael Quadretti, from Foggia, north of Rome, and Fortunata Mariannino, from Colasano in Sicily. (Courtesy Margaret Quadretti Blasi.)

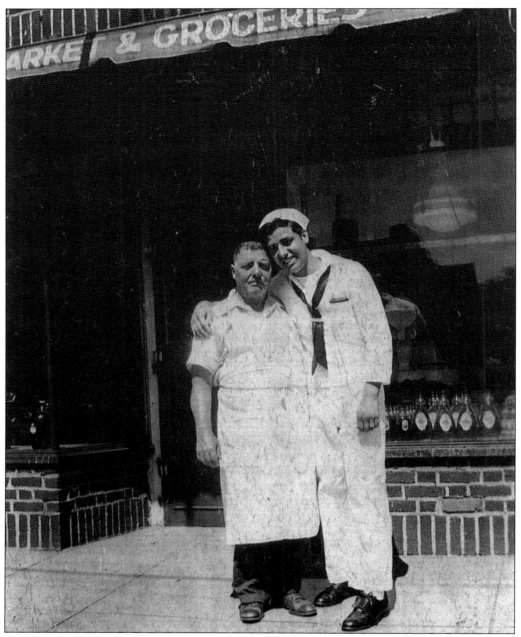

In the early 1940s, Carmine Cavallo is embraced by his son Charlie Cavallo, who was in the Merchant Marines. This photograph was taken in front of the Avondale store in Nutley. In those days, it was not uncommon for many customers to "charge" their food because they had no money. The Cavallo family is today proud that their father and grandfather helped so many Nutley families. (Courtesy Anthony Cavallo.)

Five

THE CHURCH
IN THE COMMUNITY

The first Italian Catholic parish in Newark (1866) was St. Philip Neri. By 1931, there were six Italian parishes. Processions seemed to take place every week from June until the end of October. The first recorded procession, in 1888, was for Our Lady of the Snows (Madonna della Neve), the patroness of Calabritto. Our Lady of Mount Carmel Church was founded in 1890, and St. Lucy's Church began in 1891. St. Rocco's Church, established in 1899, was a reproduction of St. Blasius Church, Lendinara, Italy. It started as a basement church in 1927 and took 10 years to complete.

St. Anthony of Padua was Belleville's Italian Roman Catholic church, built in 1901, although congregants had been meeting since 1899. In addition to the men's and women's societies honoring St. Bartolomeo, the Mother of Sorrows Society and the Holy Name Society were prominent in the early 1900s. St. Anthony and St. Liberatore were other saints honored with processions through Belleville streets.

Other Italian churches were the First Italian Baptist Church of Silver Lake (1914) and the Belleville Assembly of God, which began with meetings in homes on Clinton Street, Union Avenue, and William Street.

Probably the most well known of Nutley's Italian churches is Holy Family Church, established in 1909 by the Reverend Alphonso de Santola. The rectory was built in 1937, the school in 1950, and the convent in 1951. Msgr. Anthony Di Luca was the pastor for 35 years. Less well known was the Italian Pentecostal Church. In September 1918, a group of congregants from the Italian Pentecostal Church in Passaic began to hold open-air services in Italian every Sunday at 3:00 p.m. at the intersection of Bloomfield Avenue and Harrison Street in Nutley. After a few weeks, the group was invited to a home on Bloomfield Avenue. In May 1920, Ralph Freda, of 40 Milton Avenue, became the first local leader of the congregation. Over time, the church was known as the Nutley Assembly of God.

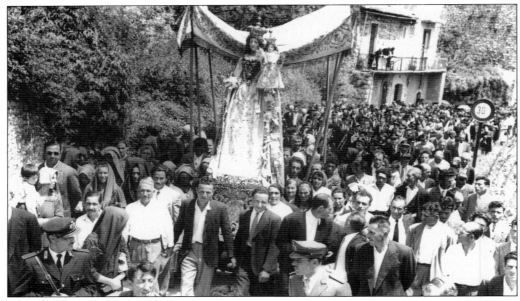

The citizens of San Rufo, Salerno, Italy, walk at the annual Our Lady of the Rosary Feast, around 1925. Teresa Errico Grasso began a collection in Newark for the feast. Proceeds were sent back to Salerno every year. When Grasso passed away, the collection was continued by her daughter, Mary Zelanti. (Courtesy Michael Vargas.)

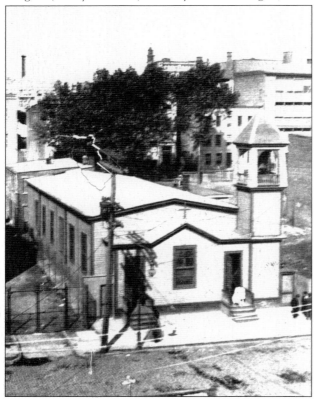

This is an old photograph of the first St. Lucy's Church, around 1925. The new church opened in 1926. Early on, St. Lucy's Church had societies representing various towns in Italy; a school; and a fife, drum, and bugle corps, founded in 1924. Msgr. Joseph Perotti led the parish from 1899 to 1933. Rev. Gaetano Ruggiero served from 1934 until his death in 1966. Msgr. Joseph Granato and Fr. Joseph Nativo began in 1955 and 1956. (Courtesy Msgr. Joseph J. Granato.)

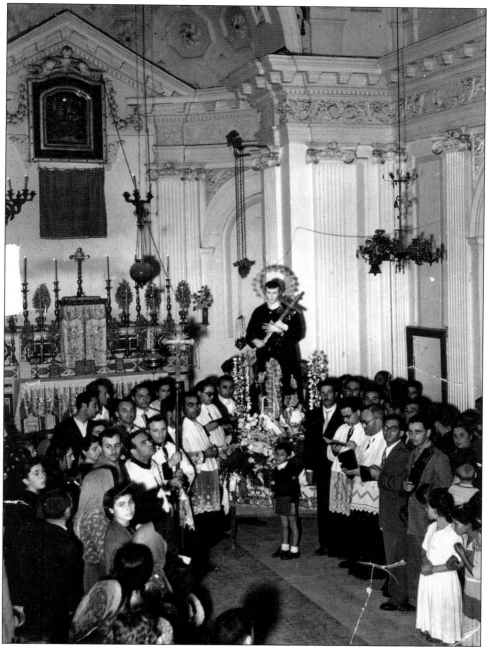

This 1952 photograph is of a church in Caposele, Italy. The statue of St. Gerard can be seen. Caposele is also home to the Basilica di San Gerardo Materdomini, the small medieval church where Gerard Maiella had lived in the 18th century. The photograph was sent to Gerardina Farina, whose son Alfonso was serving in Korea. The Italian inscription on the back refers to the boy in front of the statue (her nephew) and reads, "Nicola is at the feet of St. Gerard for you and your Alfonso, praying that he returns to you soon so that you can be at peace." (Courtesy Susan Berman.)

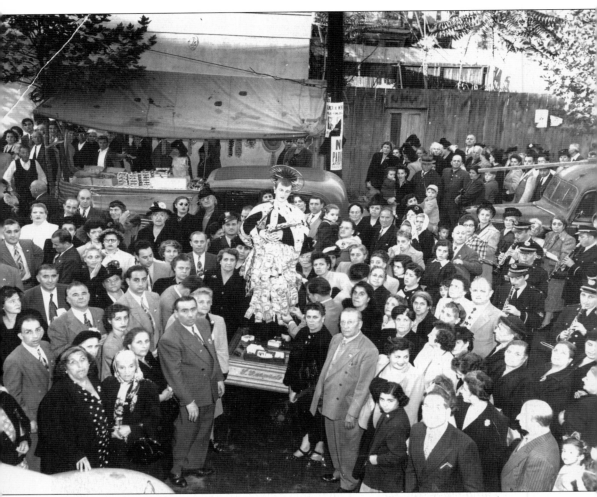

The Feast of St. Gerard, St. Lucy's Church, is shown here in the 1940s. St. Gerard is a patron of expectant mothers. Mothers often dressed their children in the clothing of St. Gerard. They followed behind the statue marching in the procession. The statue would stop at many houses in the neighborhood, and the faithful would show devotion for St. Gerard by pinning flowers and money on the saint. Gerardo Spatola Sr. chaired the St. Gerard feast in the early 1900s. He went to New York City to pick up the statue of St. Gerard, shipped from Italy, in 1898. The shipmaster finally located the statue, after poring over the passenger list for hours, thinking Gerardo Maiella was a passenger. Gerardo Spatola Jr. also chaired the feast for many years. Geta Spatola organized and served as president of the ladies guild, and her son Gerald O'Connor started the men's society. (Courtesy Spatola family.)

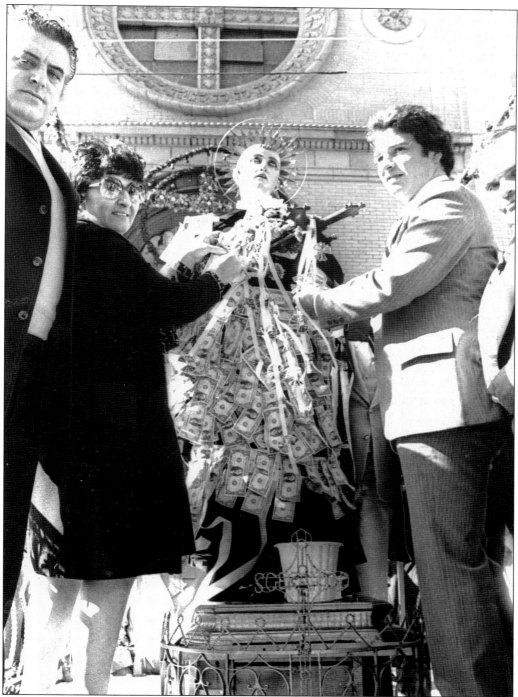

Today St. Lucy's Church still celebrates the Feast of St. Gerard every October 16, with several days of prayer, celebration, and processions through the streets. Thousands of the faithful attend. In the 1920s, huge, elaborate candles would be carried, as an indication of humility and respect, and many walked barefoot in the procession. (Courtesy Spatola family.)

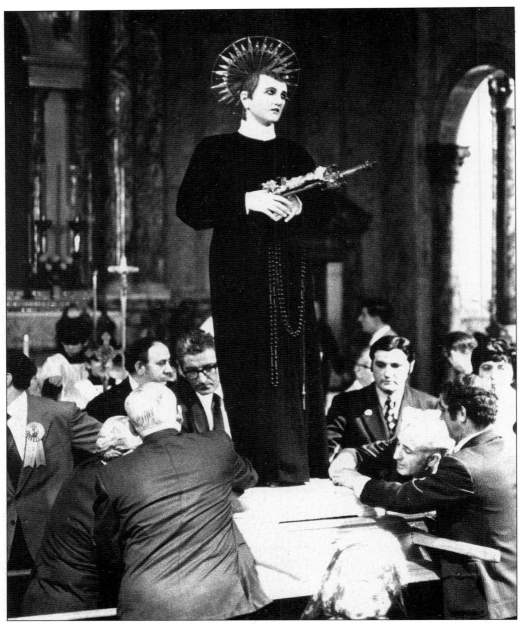

The statue of St. Gerard in St. Lucy's Church is being prepared for the procession through the streets. The statue wears real clothing. Each year before the feast, a new cloth habit, like the one he wore in life, is made and the old one is cut into pieces and distributed to the faithful. (Courtesy Rev. Thomas D. Nicastro Jr.)

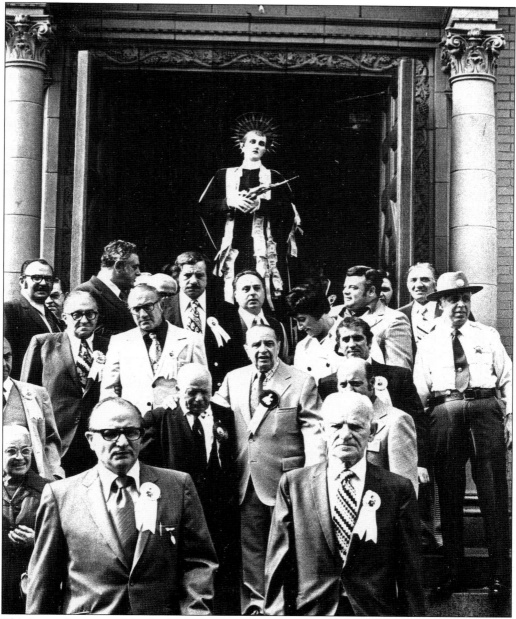

This is another view of the St. Gerard procession. The statue of St. Gerard is leaving the church with money pinned to his robes. (Courtesy Rev. Thomas D. Nicastro Jr.)

This is the St. Gerard Ladies Guild participating in the St. Gerard procession. (Courtesy Rev. Thomas D. Nicastro Jr.)

The Neopolitan Christmas *presepio* at St. Lucy's Church was a Christmas tradition. The old nativity scene consisted of more than 100 cloth and terra-cotta figures, all hand made in Italy. The setting is a Neapolitan village and was the creation of Luigi Penza, church sexton for over 50 years. This photograph is probably from about 1950, just before the old-style *presepio* was changed. (Courtesy Rev. Thomas D. Nicastro Jr.)

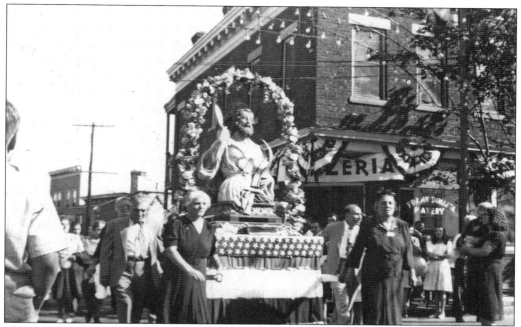

The procession of St. Bartolomeo was eagerly anticipated every August in Silver Lake in Belleville. Here around 1951, the procession pauses at Heckel and Jeraldo Streets. The Bonavita Bakery is in the background. Rosina DiBlasio Pico, on the front left, had served as president of the Women's Society of St. Bartolomeo. The society was made up mostly of women from the town of Cassano. (Courtesy Paula Zaccone.)

The feast and procession for St. Bartolomeo involved food, music, and fireworks. People pinned money to the statue. Others donated huge bouquets of flowers adorned with money-covered ribbon. Women sometimes embraced the statue and wept. Seen here around 1951, the procession is on Franklin Street in front of St. Anthony's Church. (Courtesy of Paula Zaccone.)

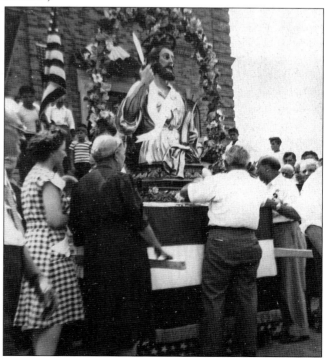

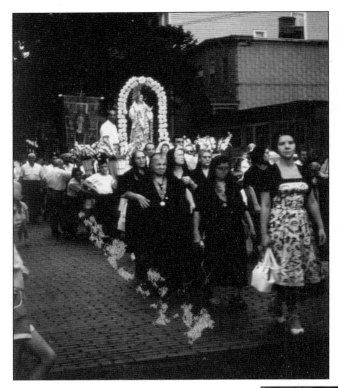

Here is a view of the procession of St. Rocco in 1957. Women members of St. Rocco's Church join the procession on South Eighth Street in Newark. Several women are wearing black. The color guard of St. Rocco's cadets (the Centurions) was also a part of this procession, as was Father Masiello and girls dressed in their first communion dresses. (Courtesy Lawrence Scaniello.)

Members of the Vallatese Society, of Eighth Street and Fifteenth Avenue, present the basket to the feast committee, in 1957. Some are adding more donations. Notice the money pinned to the statue. (Courtesy Lawrence Scaniello.)

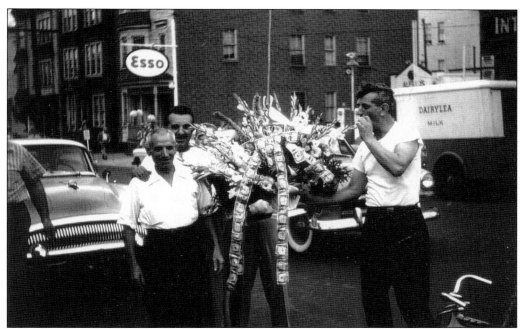

Club members of the Vallatese Society, of Eighth Street and Fifteenth Avenue, retrieve the gift basket and donations hanging from a wire at the procession of St. Rocco, 1957. Notice the money flowing down like a ribbon from the basket of flowers. (Courtesy Lawrence Scaniello.)

Members of the Vallatese Society on Eighth Street and Fifteenth Avenue are watching a game of bocci in the rear yard of the club in 1957. The Vallatese Society organized the St. Rocco Procession every year. Members and neighbors would wait outside the club for the arrival of the procession. (Courtesy Lawrence Scaniello.)

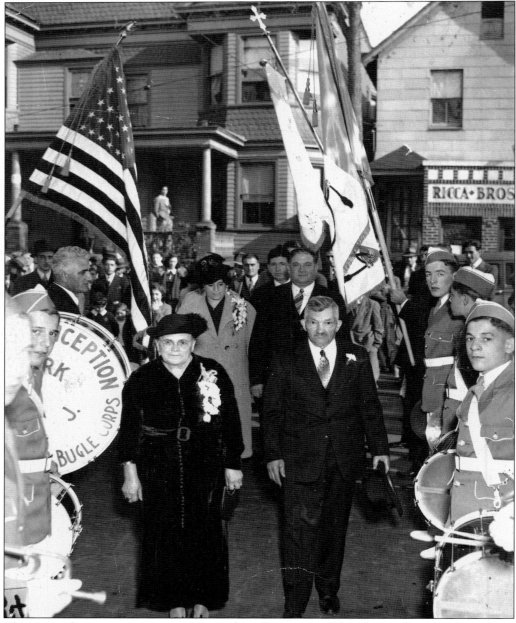

This is a religious procession at Immaculate Conception Church, on Summer Avenue, in Newark, around 1940. Filomena and Giovanni DeCarlo are in the foreground. (Courtesy Phyllis Coldebella.)

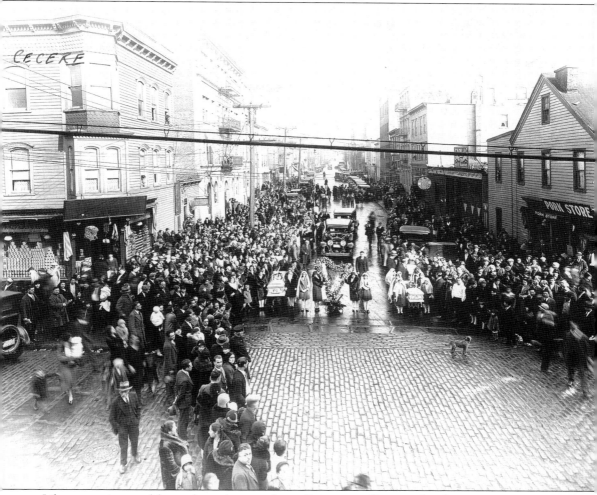

Like processions and feasts, funerals were often religious as well as social and community events. Early on, wakes were held at home. Here is a photograph of a large funeral (Cecere) in the streets of Newark in the 1930s conducted by the Spatola Funeral Home. Two young children had been killed; notice the two small white coffins. (Courtesy Spatola family.)

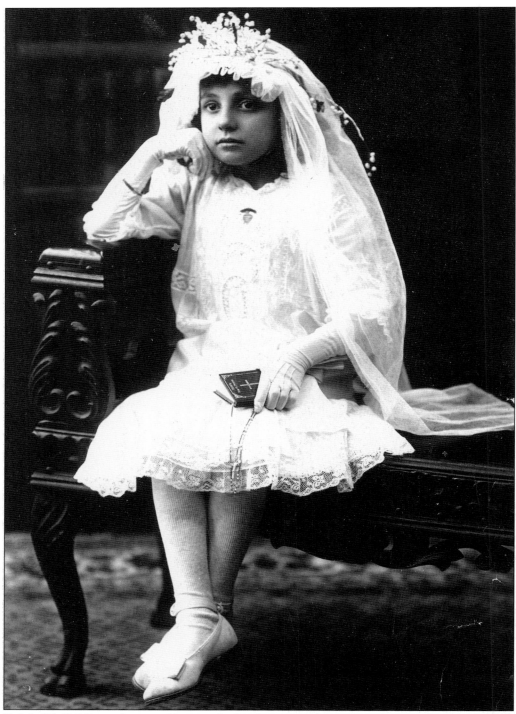

Dalida "Dolly" Senerchia, age 10, poses for her first communion portrait, around 1912. She later married Ulisse Senerchia, a well-known concert pianist, who performed in the tristate area. (Courtesy Elissa Senerchia.)

This first communion photograph is of Rose (Rosina) Tronolone with two of her sisters, around 1914. Rose, born 1904, was baptized at St. Lucy's Church. She graduated from Barringer High School and went on to get a teaching certificate from Newark State Normal School (Kean University). Rose taught kindergarten in Newark before becoming a nun. She was one of eight children of widower Antonio Tronolone. (Courtesy Richard Cummings.)

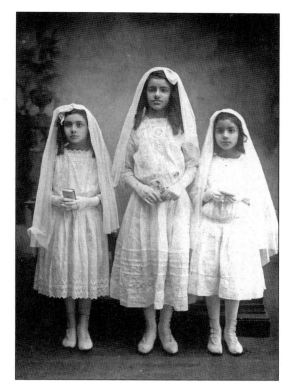

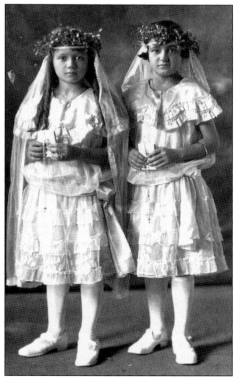

This confirmation picture was taken about 1924 in Nutley. Eileen Crecca Poiani was about 12 years old, and she is shown here with a cousin, Dorothy Petillo. Eileen was raised by her aunt, and she and her cousin were only six months apart in age. (Courtesy Eileen L. Poiani.)

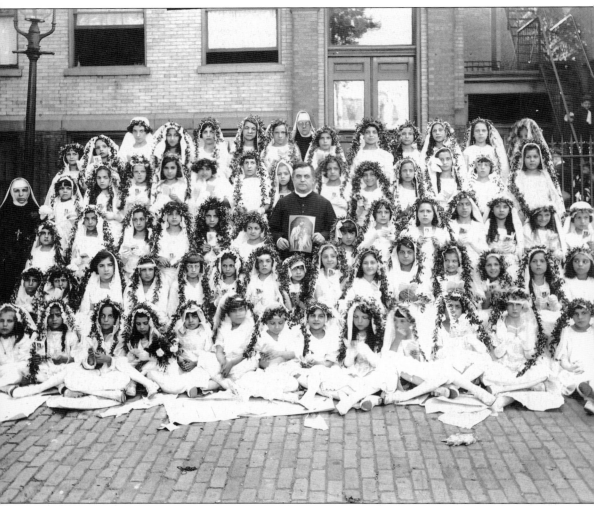

This first communion picture was taken in front of the convent at St. Lucy's Church in the 1920s. It was Leah Fusco's first communion. Fr. Gaetano Ruggiero is in the center. Notice the child peering from the balcony in the upper right corner. The girls wore white dresses and distinctive flowered headdresses, shown in detail on the next page. (Courtesy Lester Fusco.)

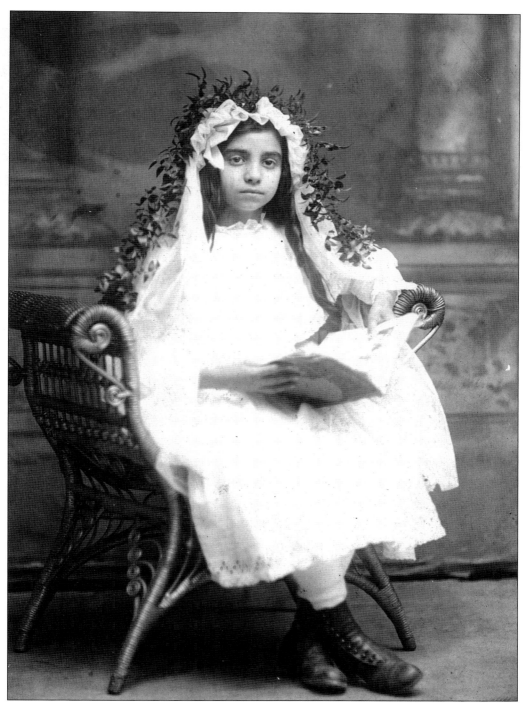

This is a portrait of Leah Fusco on the occasion of her first communion. She was the granddaughter of Salvatore Fusco from Benevento. Her great uncle Anthony Fusco, Salvatore's brother, was a scholar, author, and priest in Italy. A statue was erected in his honor in Torrecuso, Benevento, in 1956. (Courtesy Lester Fusco.)

Paul Grasso is at his first Holy Communion in 1941 at St. Francis Xavier Church in Newark. Young Grasso grew up in Newark. He served in the U.S. Army beginning in 1955. Upon his return, Grasso followed his father's footsteps as a jeweler in Rutherford. Grasso married Pauline Williams. They lived in Pine Brook, New Jersey, with their five children. His grandmother was Maria Josephine Grasso (see page 14). (Courtesy Michael Vargas.)

Pietro Ruffo is shown here with his godson Joseph LaMoglia ("Moore"), in Nutley, around 1923. From 1948 to 1954, Ruffo served as a trustee on the board of the Italian Pentecostal Church of Nutley, then on Milton Avenue. (Courtesy Steven Mairella.)

First communion day was an important rite of passage for Italian American families. Here three cousins from the Raimo and DeCarlo families pose in front of Franklin School around 1947. First communion took place at St. Michael's Church. Notice the knickers, typical Sunday best dress for the boys. (Courtesy Angela M. Raimo.)

This is the Shrine of Our Lady of Fatima and Lady of Lourdes at Holy Family Church in Nutley, when the old church was on Brookline Avenue. The parish started in 1909. In this 1951 picture, Eileen Poiani (daughter of Eileen Crecca and Hugo Poiani) commemorates her first communion. (Courtesy Eileen L. Poiani.)

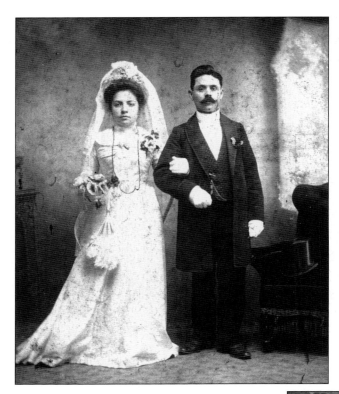

Around 1900, Gerardo Spatola Sr. married his bride, Agata, in Newark. Gerardo's father, Domenico Spatola, had come to Newark in the early 1880s. Gerardo started a funeral business in 1893. (Courtesy Spatola family.)

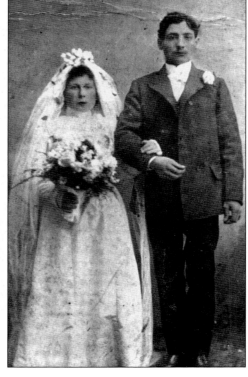

The wedding of Angelo Vitale and Columba Guarino, who were both born in Teora, took place at St. Lucy's Church in 1901. They lived in Newark until 1923 and then opened a grocery store in Verona called Vitale's Market. (Courtesy James Curran.)

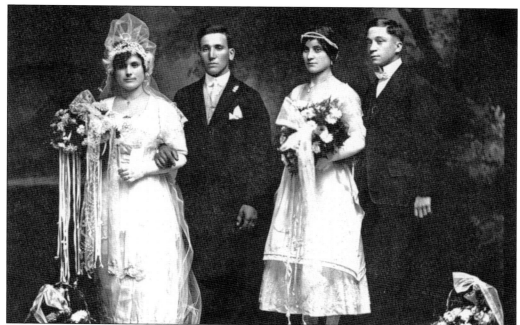

St. Lucy's Church, in 1916, was also the setting for the wedding of Angelo Sperduto, age 24, and Philomena Zarra, age 22. They knew each other in Teora, Italy, and then married here. The fabric from the beautiful handmade gown was later used to make communion dresses for the children in the family. Angelo was naturalized in 1944. (Courtesy Marianne Pepe Murray.)

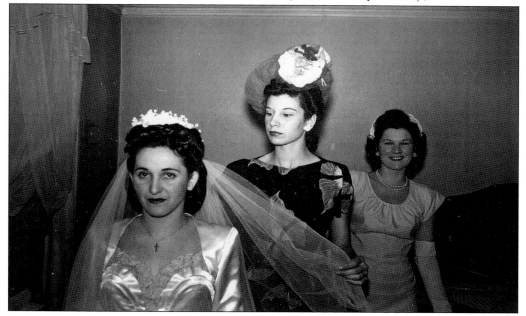

Marianna Sperduto, daughter of Angelo and Filomena above, is shown on her wedding day in 1947. She is with an unidentified friend, who designed and made her gown, and Louise Marchegiano, maid of honor, who later became her daughter's godmother. It was an Italian tradition for gowns to be handmade. (Courtesy Marianne Pepe Murray.)

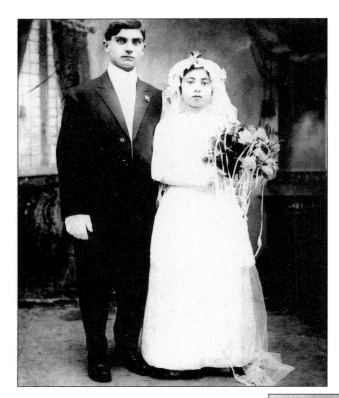

Maria Nicola (Anna) Liloia, age 19, and Domenico Miano, age 21, were married in St. Lucy's Church by Msgr. Joseph Perotti in 1914. Domenico was later naturalized at age 44, in 1937. Maria Nicola was naturalized at age 46, in 1942. Domenico can also be seen in the cover photograph. (Courtesy Rev. Thomas D. Nicastro.)

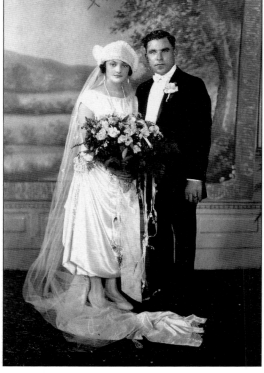

Margaret Damiano and Edward Viviani married in 1924 at St. Leo's Church in Irvington. Margaret was 17, and her parents had to sign a permission form. Edward was 23 and lived "Down Neck" at 61 Downey Street. Edward was born in 1901 to Ignazio Viviani and Josephine Spagnuolo. Ignazio had emigrated in 1893 from Santa Margherita, Sicily. He drove a buggy delivering soda. (Courtesy Joseph Viviani.)

Rose De Capua Spatola and Gerardo (Jerry) Spatola Jr. pose on their wedding day in 1926 at St. Lucy's Church. (Courtesy Spatola family.)

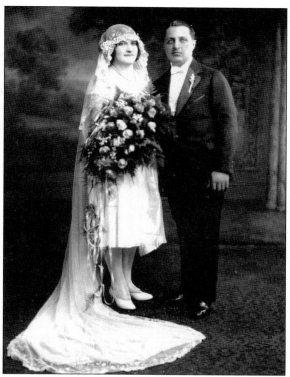

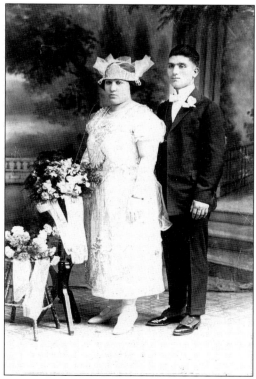

Pietro Ruffo and Angela Rosa Russo were married in 1923 in Nutley. Both had emigrated from Calabria, Pietro in 1921 at age 20, and Angela in 1899 at age five. They raised seven children on a small farm on Milton Avenue (Nanny Goat Hill) in Nutley, where they all lived in a two-and-a-half-room home with Pietro's grandfather Francesco Liguori, who had come from Acri in 1894. (Courtesy Steven Mairella.)

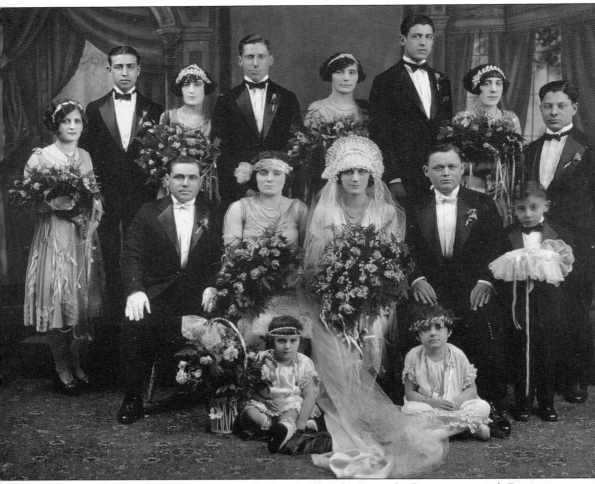

This wedding took place in 1926 at St. Lucy's Church. Pasquale Ciccone married Giovanna Ventre. The maid of honor was the bride's sister, Elizabeth Ventre Stefanelli, and Elizabeth's husband, Enrico Stefanelli, was the best man. The flower girls are the bride's nieces, Alderina Stefanelli and Erma Perillo. (Courtesy John Rendfrey.)

Olga Zinicola and Rocco Tolve appear on their wedding day, 1931. Rocco emigrated, as did Olga's parents, from Italy. They were married in the Italian Pentecostal church on Milton Avenue in Nutley, later known as the Nutley Assembly of God Church. (Courtesy Gerard Tolve.)

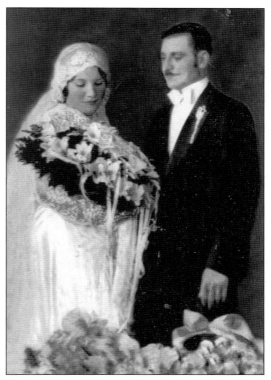

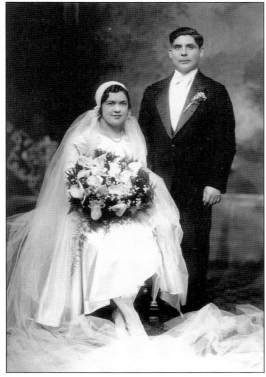

Our Lady of Mount Carmel Church was the setting for the wedding in 1930 of Josephine Fiducia and Joseph Amoscato. The "Little Cathedral of Down Neck," at 259 Oliver Street, played a big part in the lives of the Italian families. The priests were Italian, and confessions and Mass prayer responses were in Italian. Josephine and Joseph lived at 69 Madison Street. Joseph came from Calatafimi, Sicily, about 1906, at age eight, and lived on Nichols Street. (Courtesy Maryann Leo.)

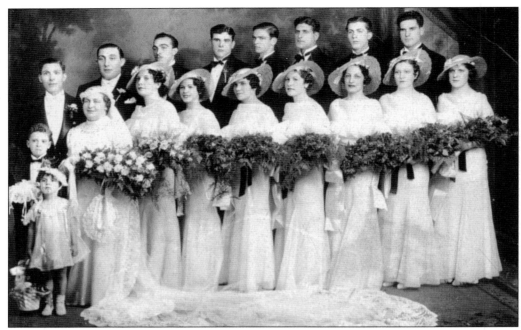

Maria Ditta Alfano and Stefano Alfano married in 1935 in St. Rocco's Church basement, because the top of the church was not yet built. Maria's father, Antonio Ditta, came through New Orleans. He worked in the railroad and in meatpacking. He sent for Maria, age 19, from Vita, Sicily. Stefano emigrated from Cattolica Avrealea, also Sicily. (Courtesy Emanuele Alfano.)

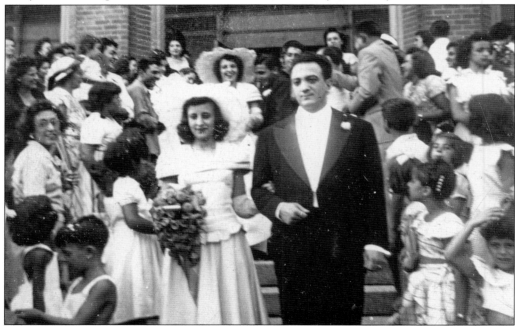

The wedding of Caroline Pico Zaccone took place around 1938 at St. Anthony of Padua Church in Belleville. Zaccone was the daughter of Giovanni and Rosina DiBlasio Pico of Heckel Street in Belleville. (Courtesy Paula Zaccone.)

This is Dolores Giordano and her bridesmaids on her wedding day in 1945 at St. Michael's Church, Newark. Giordano married Oliver D'Amato, son of Pietro D'Amato and Francesca Marmo, immigrants as teenagers from the province of Salerno in 1888. (Courtesy Oliver D'Amato.)

It was tradition for brides to pose in front of the beautiful fireplace at the Military Park Hotel, as in this 1959 photograph of Margaret Quadretti Blasi. Blasi's wedding took place at St. Rocco's Church, and the reception was at the Military Park Hotel, located where the New Jersey Performing Arts Center now stands. (Courtesy Margaret Quadretti Blasi.)

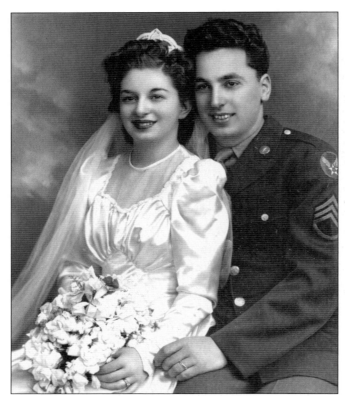

Pictured here are Frank and Dorothy Cocchiola, married in 1944 at Holy Family Church. Frank was the youngest son of Generoso and Anna Cocchiola. Generoso emigrated from Torrela DiLombardi in 1901 at age 16. (Courtesy Joanne Cocchiola.)

Msgr. Anthony Di Luca is seen here presiding at the wedding of Frank and Dorothy Cocchiola in 1944 at Holy Family Church, where many generations of Nutley residents were married. (Courtesy Joanne Cocchiola.)

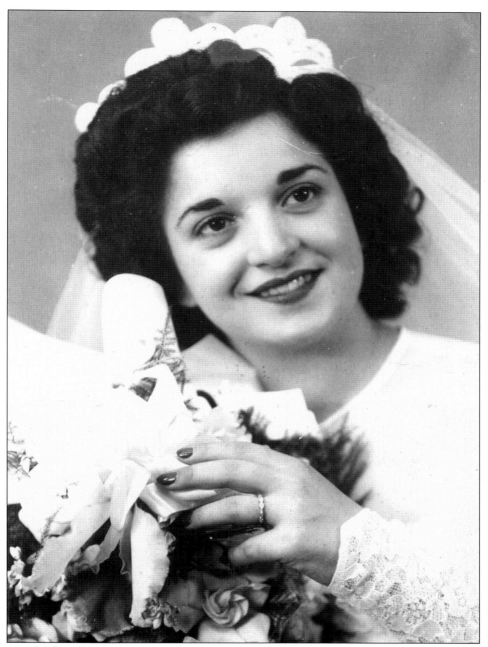

The bride (1946) is Caterina Malvaso, age 22. She married George Moran, a sailor from Pennsylvania, at Sacred Heart Church in Vailsburg. The celebrant was Father Connell. The reception was a "sandwich wedding"—sandwiches, drinks, and cake instead of a formal sit-down meal, served at Liberty Hall in Newark. Moran came back a hero from World War II, as his ship had been torpedoed in the South Pacific. Caterina and George were sweethearts before he left, but not allowed to marry, as her father feared George might not return. In that case, Caterina would have been a widow, never to remarry, and probably would have worn black for years, according to custom. (Courtesy Francine Aster.)

The St. Rocco's Centurions pose around 1954 in front of St. Rocco's Church in Newark. Standards were high. It is said that on one occasion, when the uniforms were not returned prior to a parade, tuxedos were rented for everyone. Emanuele Alfano is in the front row, center, with three drums on either side. (Courtesy Emanuele Alfano.)

The St. Rocco's Church Drum and Bugle Corps (also known as the Centurions) performed at the Holy Name Day parade in this *c.* 1954 photograph. Fr. Michael Fuino and Fr. Gabriel Longo stand at the intersection of Hunterdon Street and Fourteenth Avenue. Father Longo is credited with organizing the drum and bugle corps. (Courtesy Margaret Quadretti Blasi.)

This is another view of the St. Rocco's Church Drum and Bugle Corps, around 1954. (Courtesy Margaret Quadretti Blasi.)

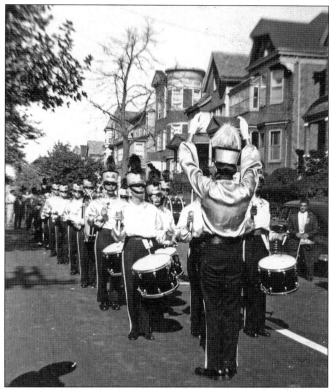

St. Rocco's Color Guard members Margaret Quadretti Blasi and Connie Bucceroni perform around 1954. (Courtesy Margaret Quadretti Blasi.)

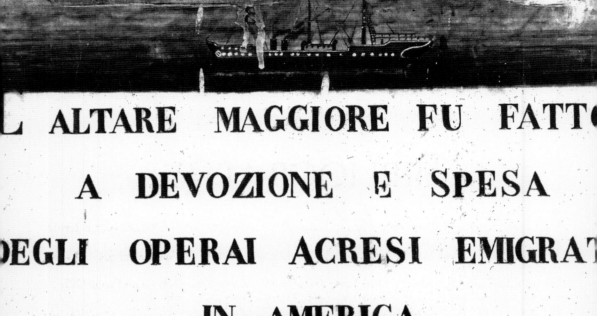

L ALTARE MAGGIORE FU FATTO

A DEVOZIONE E SPESA

DEGLI OPERAI ACRESI EMIGRAT

IN AMERICA

1897

This plaque reads, "The main altar was constructed as a result of the devotion and donations of workers from Acri who emigrated to America." This plaque is dated 1897. The translation was made by Steven Mairella, who photographed the plaque in the Church of the Beato Angelo in Acri on his 2007 trip there. It was blown up and displayed at the 2007 Nutley Columbus Day ceremony, attended by the mayor of Acri, among other Italian dignitaries. Past and present were united. (Courtesy Steven Mairella.)

BIBLIOGRAPHY

Carnevale, Joseph William. *Americans of Italian Descent in New Jersey.* Clifton: North Jersey Press, 1950.

Cervasio, Joseph. *Bad News on the Doorstep: Inspired By a True Story.* Bloomington, Indiana: AuthorHouse, 2004.

Churchill, Charles. *The Italians of Newark: A Community Study.* New York: Arno Press, 1975.

Demmer, John. *Nutley.* Dover, New Hampshire: Arcadia Publishing, 1997.

Ferrante, Constance P. "A Walk through Time: A Symbolic Analysis of the Devotion to St. Gerard Maiella." PhD diss., Rutgers, the State University of New Jersey, 1993.

Immerso, Michael. *Newark's Little Italy: The Vanished First Ward.* New Brunswick, New Jersey: Rutgers University Press and Newark: the Newark Public Library, 1997.

LaGumina, Salvatore. *The Humble and the Heroic.* Youngstown New York: Cambria Press, 2006.

LoCurcio, Vincent, Rich O'Connor, Marilyn Peters, Fred Van Steen, and Jean Van Steen. *Celebrating One Hundred Years of Nutley: 1902–2002.* 2002.

New Jersey Italian and Italian American Heritage Commission. Demographic Distribution of New Jersey Citizens of Italian Descent, 2005.

New Jersey Writer's Project. *A History of Belleville, 1935–1940.*

Rankin, Edward S. *Indian Trails and City Streets.* Montclair, New Jersey: the Globe Press, 1927.

Starr, Dennis. *The Italians of New Jersey: A Historical Introduction and Bibliography.* A Publication of the New Jersey Italian and Italian American Heritage Commission, 2003.

Rosa, Kenneth J., ed. "The Recollections of Peter B. Mattia: The Early Italian Settlers in Newark and the City of Newark in the Late 1800's." Unpublished manuscript, 1985.

ACROSS AMERICA, PEOPLE ARE DISCOVERING SOMETHING WONDERFUL. *THEIR HERITAGE.*

Arcadia Publishing is the leading local history publisher in the United States. With more than 3,000 titles in print and hundreds of new titles released every year, Arcadia has extensive specialized experience chronicling the history of communities and celebrating America's hidden stories, bringing to life the people, places, and events from the past. To discover the history of other communities across the nation, please visit:

www.arcadiapublishing.com

Customized search tools allow you to find regional history books about the town where you grew up, the cities where your friends and family live, the town where your parents met, or even that retirement spot you've been dreaming about.